CINCINNATI HOOPS

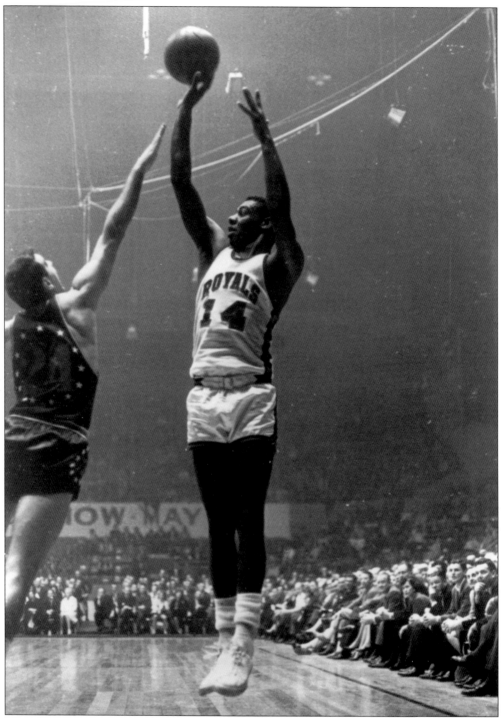

There has never been a player like Oscar Robertson. Arguably the greatest all-around hoopster in basketball history, Robertson was a three-time college player of the year at the University of Cincinnati from 1958 to 1960, and then played professionally for the hometown Royals in his journey to a Hall-of-Fame career.

CINCINNATI HOOPS

Kevin Grace

ARCADIA
PUBLISHING

Published by Arcadia Publishing
Charleston SC, Chicago IL, Portsmouth NH, San Francisco CA

Printed in the United States of America

Library of Congress Catalog Card Number: 2003111248

For all general information contact Arcadia Publishing at:
Telephone 843-853-2070
Fax 843-853-0044
E-mail sales@arcadiapublishing.com
For customer service and orders:
Toll-Free 1-888-313-2665

Visit us on the Internet at www.arcadiapublishing.com

Dedicated to Jack Klumpe, a friend whose photographic skills allowed such extraordinary documentation of Cincinnati sports for forty years, and whose kindness allowed reproduction of several of those images for this book.

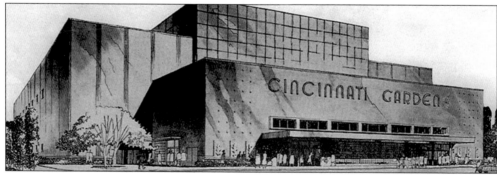

The venerable Cincinnati Gardens has been the palace for much of local basketball history over the decades. The Gardens opened on February 22, 1949 with a hockey game, the sport for which it was primarily constructed. Not long after, however, the University of Cincinnati, Xavier University, and Miami University hoops squads matched up there on a regular basis. In the decades since, the arena has also hosted high school basketball, the Cincinnati Royals, the Cincinnati Slammers, and the Harlem Globetrotters.

CONTENTS

ACKNOWLEDGMENTS

Thanks for information, assistance, and encouragement go to Dana Blackwell, Robert Bradley and the members of the Association of Professional Basketball Researchers, Donn Burrows, John Erardi, Suzanne Finck, A.J. Friedman, Robert E. Glass of Centre College, Margaret Gonsalves of Springfield College, Greg Hand, Andrew Higley, Mary Jo Huismann, Katherine Lindner, Brittany Moore, Kevin Proffitt, Don Heinrich Tolzmann, Jack Twyman, Lisa Ventre, Tom White, the sports information staff of the Xavier University athletic department, and my editor at Arcadia, Jeffrey Ruetsche, who has done a great deal to document the sports heritage of the Midwest.

And, thanks also to my wife, Joan Fenton, and the starting five: Sean, Bonnie, Lily, Josh, and Courtney.

INTRODUCTION

A friend of mine, Greg Hand, once wrote that basketball was a game invented in 1891 as a placeholder, that James Naismith and the YMCA Training School intended it as "a temporary pastime for the real athletes while snow covered the playing fields." That's true. Naismith's directive was to develop an indoor sport to keep the students interested and well behaved, after football and before baseball and track & field. What happened in the next decade to the 20th century probably raised his eyebrows. What changes occurred in his game in the next century probably raised his ghost. Basketball, the game invented for white Christian males, very rapidly became a sport as well for women, African Americans, Jewish immigrants, urban poor, high school students, and collegians.

For the most part, Naismith would have welcomed the changes, and he did in fact during his lifetime, especially the embrace of the game by all levels of society. He didn't like very much the emphasis on the role of the basketball coach, and frowned at the notion of professionalism (the first pro game was played in Trenton, New Jersey in 1896). Basketball to him was to be part of an experience that educated the individual to become a worthwhile member of society.

Very few positive aspects of human culture have spread worldwide as rapidly as basketball. Much of the spread had to do with the YMCA: the physical instruction trainees under Naismith took the game across the country and around the globe. By 1892, basketball was being played in Mexico, a few years later it was in France, and a few years after that, in the Middle East and Japan. This initial spread of the game also was bolstered from time to time by an American troop culture when soldiers played the game during their military assignments abroad.

But back home in America, there are two large reasons why basketball grew, and one is very basic. Sports historian Steven Riess gave a term to the geographic environment in which basketball was able to flourish: *confined urban space*. At the core of the 19th century city—where the lower economic classes and the nation's recently arrived population tended to settle—there was little available space for recreation. During industrial and residential growth, large parks were for the most part moved to the edges of the core. Therefore, a sport like basketball that required a small area for play and minimal equipment to play it became popular among urban groups. And this dovetailed into the second reason: education. Schools

adopted basketball as part of a physical education curriculum. Settlement houses used the game to ease the transition from being an immigrant to being an American, to teach teamwork and initiative and discipline.

In Cincinnati, basketball was being played just a couple of years after its invention in Springfield, Massachusetts. Both the Cincinnati YMCA and the Covington, Kentucky YMCA across the Ohio River hosted early teams that became very strong competitors. Organizations such as the Central Turners, the Cincinnati Athletic Club, the Fenwick Club, and the Friars Club made room for the sport on gym schedules; churches like Christ Church created athletic programs that included basketball, and schools from the University of Cincinnati to Woodward High School began competitive play. By 1914, there were more than 50 gyms in the city. And, whenever there is competition, there are stakes to be considered: professional barnstorming teams were coming through town, and the under-the-table or side bets were more lucrative than gate guarantees.

The growth of basketball in Cincinnati over the decades of the 20th century saw the UC and the Xavier University teams create a rivalry that even today galvanizes the city each winter. The collegiate game follows the peculiarity of sport in higher education: unlike the rest of the world, America uses its colleges and universities to provide public sports entertainment. So, in Cincinnati, the interest in the Bearcats and the Musketeers spills off the respective campuses into the streets and neighborhoods of the city. College basketball becomes community basketball. Cincinnatians have also had the occasional flirtation with professional teams like the Slammers and the Stuff, and a somewhat long relationship with the NBA Royals (now the Sacramento Kings) from 1957 to 1972. Today, the only professional play comes from touring entertainment groups like the Harlem Globetrotters and the sponsored modern age barnstorming teams that tour each fall to play exhibition games against college squads.

Cincinnati's basketball culture is thriving, in the Deveroes Summer League; in recent high school state champions like LaSalle (1996), Roger Bacon (2002), Reading and Moeller (2003); for teams like the St. Dominic's Middle School girls, who had a perfect 29-0 record in 2003, and the young women of Taft High School who use basketball success as an impetus for classroom achievement. The game reflects popular culture, as in the Cincinnati Black Theater's local presentation of Nicholas Stuart Gray's play called "The Other Cinderella" in which the traditional glass slipper is now a basketball shoe; and in the high-tech basketball entertainment of the touring And 1 Mix team to promote a line of basketball gear (quite different than the Chuck Taylor All-Star skills clinics of two and three generations ago). And, in 2002, Cincinnati sports journalist John Erardi showed how basketball and the realities of everyday life join in one beautiful, extraordinary moment when he wrote about St. Bernard high schooler Nick Mosley. Mosley is a Special Olympian who landed a spot on St. Bernard's varsity roster. On a cold February night, he is in the lineup. And with only a few minutes left in the game, Nick Mosley gets the ball off a screen, shoots, and hits the bottom of the net. The gym erupts in cheers.

Basketball is indeed a placeholder in our lives, marking parts of our community's past and present with the squeak of a sneaker, the bounce of a ball, the heat and smell of a gym, and the intense thrill of competition. This book offers a visual sampling of that culture.

ONE

Creating a
Cincinnati Game
1891–1918

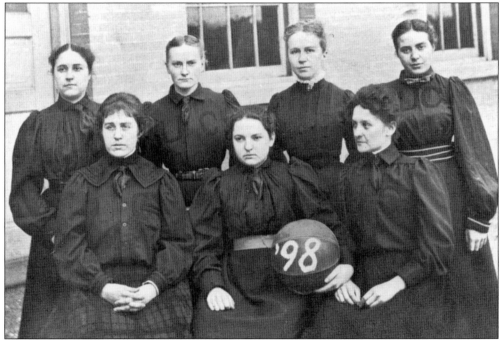

It was the women's teams of the 1890s that kept basketball alive at the University of Cincinnati as the male students struggled to make hoops a viable sport for themselves. On campus, they were called the "Bloomer Brigade" and men were prohibited from watching their games. In 1898, English instructor Edith Peck (pictured bottom row, far right) donated a basketball to the team so they no longer had to borrow the men's ball.

Dr. Luther Halsey Gulick provided the impetus for the invention of basketball. The son of prominent missionaries, Gulick earned a medical degree and in 1887 turned his attention to heading the YMCA Training School in Springfield, Massachusetts. As early as 1869, each new YMCA building had included a gymnasium, and Gulick was a firm believer in the Y credo of "muscular Christianity," the idea that sports participation helped develop spiritual character. So, in December 1891, Gulick directed an instructor, James Naismith, to develop an indoor winter sport that would engage the attention of the students. The sport of basketball was the result.

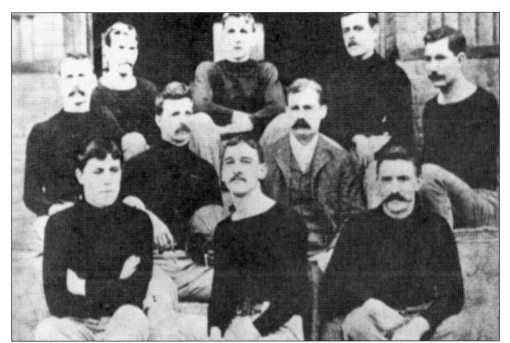

Born in Ontario in 1861, James Naismith was orphaned at nine, and dropped out of high school to become a lumberjack (and a hard-drinking one at that). When he was twenty, he decided to continue his education, and armed with a college degree he began working for Gulick in 1890. He developed basketball with nine-man teams, and devised thirteen rules for play, most of which are still in effect. Naismith is pictured here (in the suit) with his first team. Legend has it that Naismith actually played his game only twice—and was booted out both times for his rough play.

If James Naismith was the father of basketball, Senda Berenson could be considered the game's mother. As a physical culture instructor at Smith College—close to Springfield in nearby Northampton, Berenson was looking for a challenging activity for her coeds. She contacted Naismith about the particulars of the game and became a leading proponent of women's basketball, helping forge the rules that would govern play for almost a century.

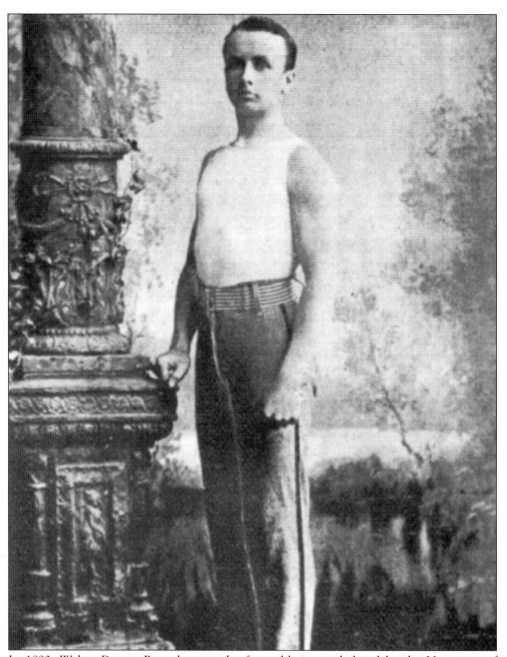

In 1893, Walter Durant Berry became the first athletic coach hired by the University of Cincinnati. An 1891 graduate of the YMCA Training School, Berry was first hired by Centre College in Kentucky to direct its athletic programs and to serve as football coach. He came to Cincinnati for the opportunity to begin medical studies as well as to coach, and in 1895 Berry became the school's first hoops coach when he organized two intramural teams, the Pig Toes and the Dew Drops. The first basketball game on campus was played on January 7, 1896— Berry's teams battling to a 1-1 tie. The men's game at UC was slow in catching on, however, and a varsity team wasn't formed until 1901. In 1897 Berry completed his medical degree and returned home to his native Massachusetts. (Photo courtesy of Centre College.)

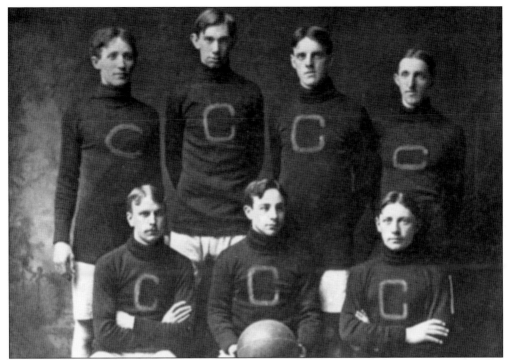

Under the leadership of Henry S. Pratt, the first officially designated "basketball coach" at the University of Cincinnati, the 1901-02 squad went 5-4 in their inaugural varsity year. Most of their games were against area amateur teams; they only played two other college teams—losing to Yale 37-9 at the Armory in Cincinnati's West End, and beating Kentucky in the campus' McMicken Gym, 31-21.

Pratt was replaced the next year by Anthony Chez, who also brought his wife, Louise, with him to UC to serve as director of women's physical culture. Chez coached for two years, compiling a record of 12-10, before he and his wife left for West Virginia University. Chez's 1904 team went 8-6 in a strong college schedule, but Chez lamented the low ceiling in the UC gym where plaster rained down on the players every time a ball hit it.

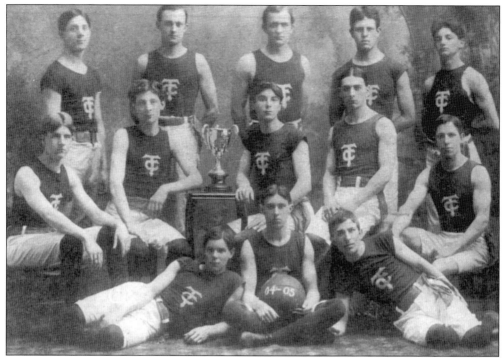

Beginning in 1848, Cincinnati's German Turners organizations promoted the joint importance of a healthy body and healthy mind. Gymnastics and physical education skills were of primary concern, but the Turners quickly embraced basketball as an integral sport in their programs. The 1904-05 Cincinnati Central Turners basketball team pose with their championship trophy won in a city tournament.

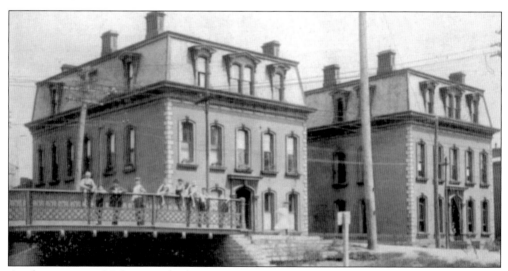

At the corners of Liberty and Plum in Over-the-Rhine, the University Settlement House organized basketball teams as early as 1899, part of its overall effort to help assimilate immigrants and to teach citizenship, job skills, and health care to children and young men and women. The working class basketball clubs generally numbered from eight to fourteen players, and called themselves by such names as the Buckeyes, the Jolly Ten, Old Glory, and the Orioles.

The original basketball was a soccer ball and the early uniforms were a modified combination of football, soccer, and track outfits, but it wasn't long in the game's history before it could claim its own distinct equipment. Essential, of course, was the proper footwear, and sporting goods manufacturers, including Cincinnati's Goldsmith firm, issued catalogs to promote their shoes.

BASKET BALL SHOE

Made of selected leather with special rubber sole. The suction caused by the peculiar construction of the sole enables the player to obtain a good purchase on the floor, a feature that should make this shoe very popular with basket ball players.

No. BB. Per pair, **4.00**

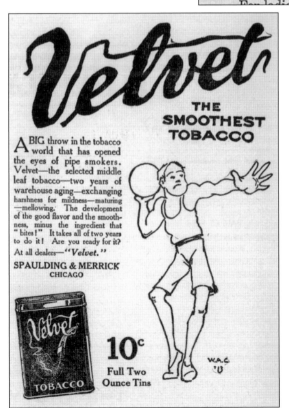

By the early 1900s, tobacco companies caught on to the image of basketball to market their products, much as they had done with baseball since the mid-1800s. The combination of sport and masculinity was a strong selling point, and Velvet Pipe Tobacco used it for football, track and field, baseball, rowing, and hoops. This advertisement is from the 1911 University of Cincinnati student newspaper.

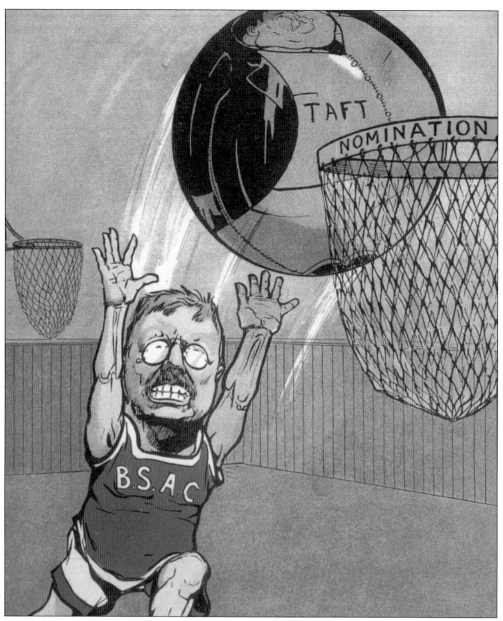

Entitled "Goal!" and published as the cover of *Puck Magazine* on March 4, 1908, this image shows native Cincinnatian William Howard Taft arching toward the hoop. Launched by his mentor and friend, President Theodore Roosevelt, Taft was heading for the Republican presidential nomination. Though the basketball shape for Cincinnati's rotund favorite son was close to the mark, Taft was more the golfing type when it came to sports.

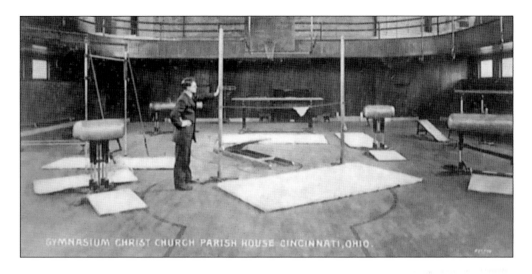

For Cincinnati's Christ Church, the Men's Club was the foundation for its early teams. Success began in the Christ Church gymnasium, seen in the postcard here, a modern building with the most up-to-date athletic apparatus. In the years between 1900 and 1925, the basketball team was a perennial contender for the city amateur championship, playing against the Jewish Settlement, the Friars Club, the L.B. Harrison Club, and archrival Cincinnati Gym and Athletic Club. Christ Church was even 4-0 in games against the University of Kentucky between 1906 and 1913. The wins didn't come without criticism, however. Christ Church was like other amateur teams in that they recruited the best available talent for their teams, sometimes paying the outstanding stars and ignoring the fact the players were not members of the Christ Church congregation, or even Episcopalians! Also pictured here is the 1919 city championship squad.

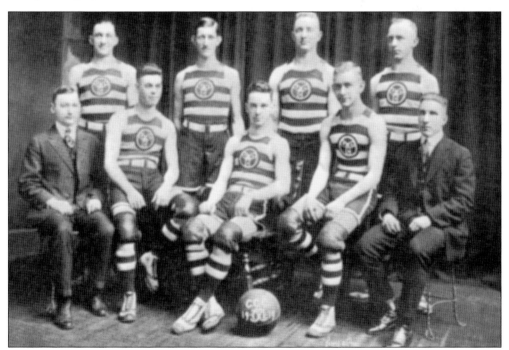

One of the nation's outstanding barnstorming teams was the Buffalo Germans, an organization begun as an amateur YMCA team in Buffalo, New York in 1895. Their astounding success in tournaments convinced the team they could make a living at playing the game, and on February 5, 1913 they blew into Cincinnati not long after ending an 111-game winning streak. They beat the Cincinnati Athletic Club 61-34, earning their guarantee of $75.00. In 1961, the entire team was inducted into the Basketball Hall of Fame.

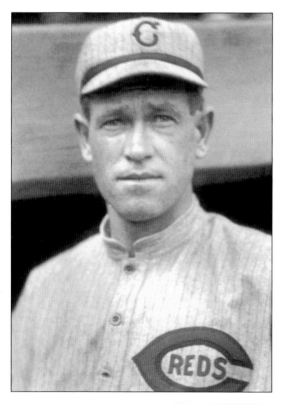

Baseball player Hal Chase did what other ballplayers of his era did: he barnstormed during the off-season. The difference was that Chase did it with a basketball. Playing his summers with the New York Yankees from 1905 to 1913, Chase's winters were spent with Hal Chase's All-Star Five. In the early spring of 1913, the squad came to Cincinnati to play the Cincinnati Athletic Club "Gyms." Given that Chase was one of the most crooked baseball players of all time by gambling on his own games, and that side bets were an accepted part of barnstorming basketball action, it's probable he bet on his own hoops contests as well. Chase played first base for the Reds from 1916 until 1918, when Reds owner Garry Herrmann tried to get him ousted from Organized Baseball.

Established as the Young Men's Gymnastic Association of Cincinnati in 1853, by the turn of the 20th century, the Cincinnati Athletic Club was a prominent organization in local sports, sponsoring gymnastic, track & field, football, baseball, and boxing teams. And, by the time they moved into their new building on Shillito Place in 1903, basketball was very popular as well. The club, which appealed to the movers and shakers in the city, boasted a membership of the most prominent up-and-coming businessmen, including at points throughout its history, four Presidents of the United States: Rutherford B. Hayes, James A. Garfield, Benjamin Harrison, and William Howard Taft. As shown in the postcard, the businessmen may have been able to use the gym for mid-day calisthenics, but then it was turned over for some serious hoops. The CAC Pirates, of course, were involved in the same controversies with Cincinnati's other amateur clubs over "professionalism," and the disputes could become very acrimonious. Basketball was in fact a moneymaker for the club. Fifteen-cent admissions were charged, and a percentage of the gate was often negotiated with opponents.

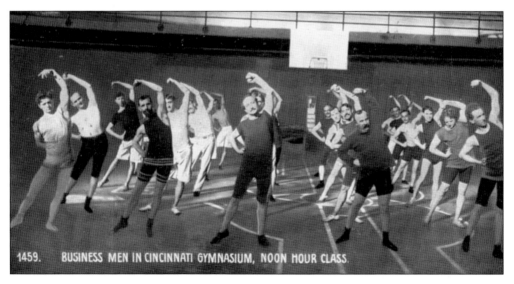

1459. BUSINESS MEN IN CINCINNATI GYMNASIUM, NOON HOUR CLASS.

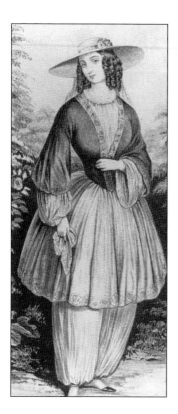

She never knew anything about basketball, and may well have never heard about the game, but Amelia Bloomer (1818-1894) had a distinct influence on the sport nonetheless. The New York women's rights activist advocated a new feminine mode of dress patterned after Turkish-style trousers. The costume was devised to give women easier movement, and as it happened, it became the athletic uniform-of-choice for Cincinnati "Bloomer Girls" and other women around the country from the 1890s to the 1920s.

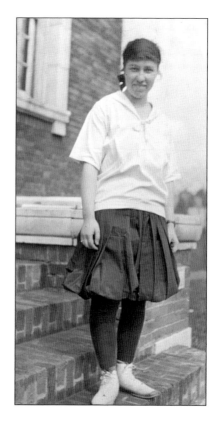

UC coed Bertha Bruckman poses in her basketball bloomer uniform in 1917. Bruckman played from 1917 to 1919 under the coaching of Marjorie Hillas, who, contrary to standards of the day, insisted on playing by men's rules on the Cincinnati home court. The women's game could get rough: in a game the previous season when UC went up against a team called the "Independents," several of the players had to leave the game because of the banging between players. UC lost two players in the game, Leona Taylor and Laura McIntire, but Julia Hammler led the Red and Black to a 14-4 victory.

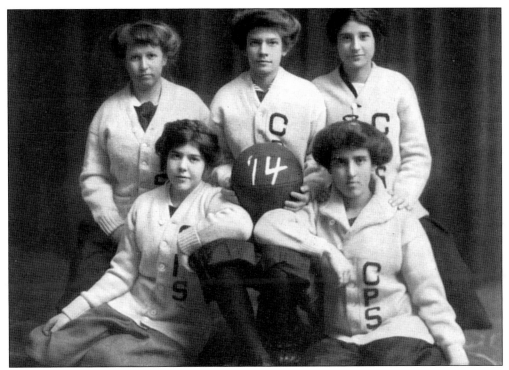

The standard uniform also included heavy woolen sweaters, as worn in this studio portrait of the 1914 girls' team at the College Preparatory School for Girls.

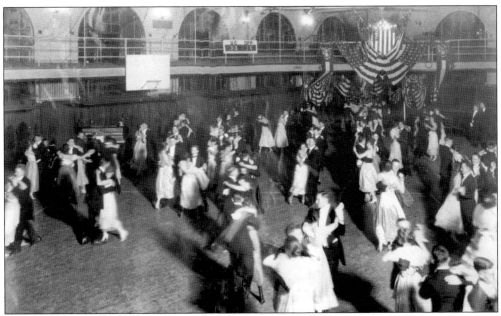

As America entered World War I in 1916, UC students held a formal dance in Schmidlapp Gym beneath patriotic bunting. Following a game that was won by UC by a score of 33-31, a piano was pushed beneath the basket and the elegantly-dressed students danced away the rest of the evening.

The parish of Holy Family Church in Price Hill was formed in 1884, and in 1911 the congregation opened a gymnasium to serve the people of the church. By this time, the Progressive Era ideals of combined mental and physical fitness was fully embraced, and physical education was added to the Holy Family School curriculum. As the parish leaders viewed it, "Education that does not recognize the proper relation of the physical to moral and mental development is regarded as seriously deficient." The parish's athletic programs extended to adults as well as children, and the basketball teams grew very popular during the winter season. These 1916 images show one of the men's squads and a girls' gym class posed beneath the hoop.

TWO

Expanding the Community of Sport 1919–1930

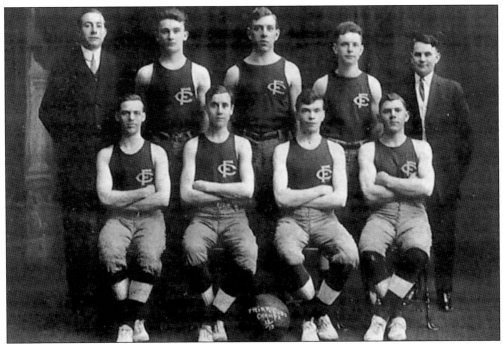

The Friars' Club of Cincinnati was one of the earliest Catholic organizations in the city to field several basketball teams as part of their athletic programs. This 1913 squad won the city's amateur championship by defeating the Cincinnati Athletic Club Gyms by a score of 30-21, establishing the tradition of strong club teams over the next two decades.

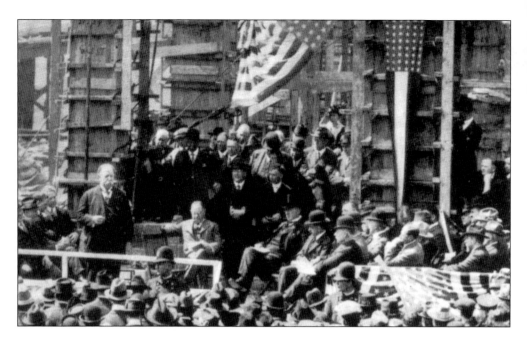

Cincinnati's downtown YMCA at Seventh and Walnut Streets had offered several athletic programs since the mid-1890s, but it wasn't until a new Y was constructed that their basketball teams would have a permanent home. Former president William Howard Taft was on hand for the laying of the cornerstone for the city's new YMCA at Elm and Canal Streets on April 7, 1917. The actual dedication was delayed until December of the following year because of World War I and the subsequent devastation of the Spanish influenza epidemic. Apparently there was big money to be had even then in sports: two workmen digging at the site struck a clay pot, spilling $12,000 in gold coins!

New Y. M. C. A. Home
Elm and Canal Sts.
Cincinnati, O.

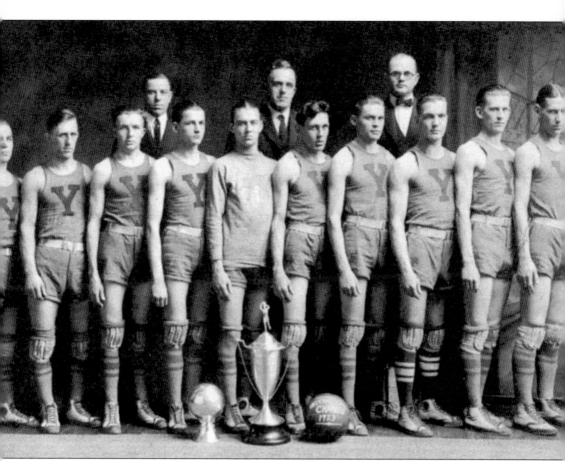

The first basketball team was coached by Carl Wilzbach, and only five players represented the squad: Joe Full, Pete Nolte, Mac McDirment, Emmett Agger, and Al Bicknaver. But the numbers grew, and from 1920 to 1930 the YMCA Wildcats were the toughest team in town, with feeder teams called the Maroons and the Ramblers. Over that decade, the Wildcats compiled a record of 298-34. Coach Wilzbach created the National YMCA Basketball Tournament, and the Cincinnati team captured the first championship in 1924, successfully defended it the next year, and won it again in 1928, the last year under the leadership of local hoops legend George Richardson. The YMCA Wildcats, as other amateur clubs did, recruited former collegians and the best local high school players.

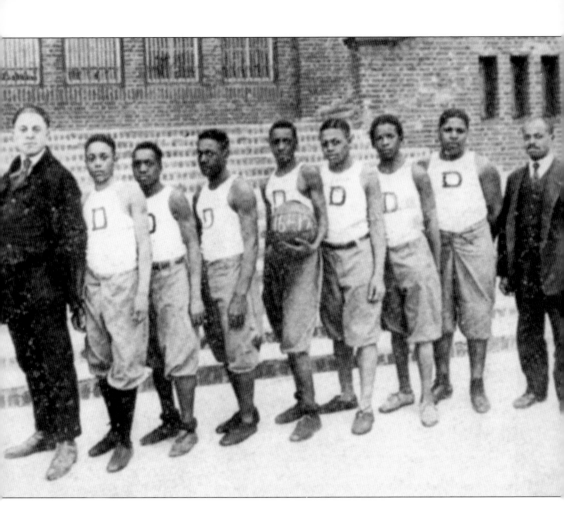

By 1920, William DeHart Hubbard was already being touted as the "community's premier athlete." Born in Cincinnati in 1904, Hubbard first showed his athletic talent as a student at Douglass School, a progressive school for African-American students that boasted a school garden, boys' cooking class, open-air classrooms, a carpentry shop, and excellent library. From the age of twelve, Hubbard entered every available track meet, winning a score of medals. Pictured here in the team photo (third from left) he also led the Douglass School to schoolboy basketball championships. From Douglass, Hubbard went to Walnut Hills High School, and then to the University of Michigan. In 1924, he became the first African-American to earn an Olympic gold medal, winning the broad jump at the Paris games. Back home in Cincinnati, he continued his athletic career with the Cincinnati Recreation Commission, and as the organizer of a barnstorming basketball team, variously called the DeHart Hubbard Five or the Cincinnati Lion Tamers. Drawing his players from the Ninth Street YMCA, an African-American Y, Hubbard's basketball teams toured the Midwest in the late 1920s, playing a variety of amateur, college, and other professional teams. In February 2003, a bronze relief sculpture honoring Hubbard was installed at the Riverfront Transit Center. (Portrait photo courtesy of Dana Blackwell.)

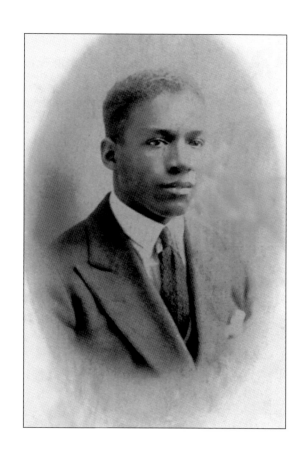

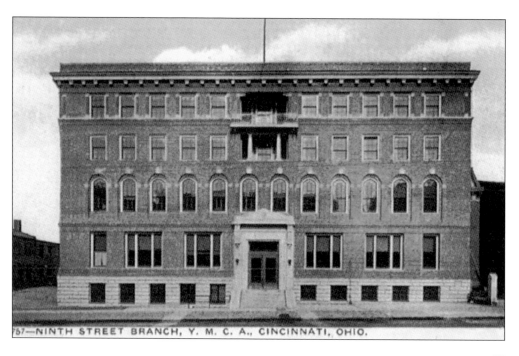

757—NINTH STREET BRANCH, Y. M. C. A., CINCINNATI, OHIO.

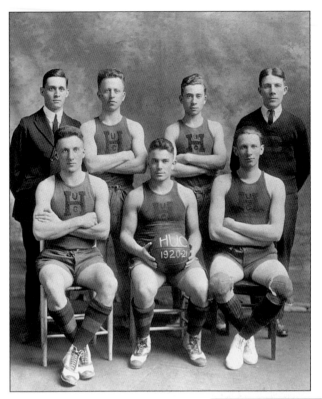

Up the hill from downtown in the Clifton neighborhood, Hebrew Union College created a team from their rabbinical students. The HUC squad typically scheduled local club and business teams, with occasional small college teams thrown into the mix. (Photo courtesy of the American Jewish Archives.)

The 1923-24 Ohio Mechanics Institute basketball team played in the school's rooftop gymnasium on Walnut Street in Over-the-Rhine, compiling a 6-10 record against high school and YMCA teams. Optimism for the next year's team was high, however, as "with the proper coaching and practice it should develop into a corker." OMI began its basketball program in 1914, and would continue until it became a college of the University of Cincinnati in 1969.

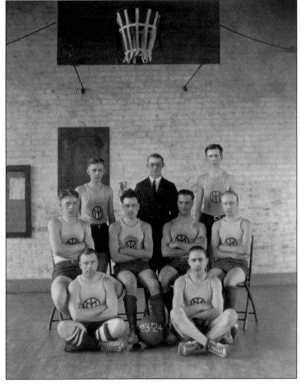

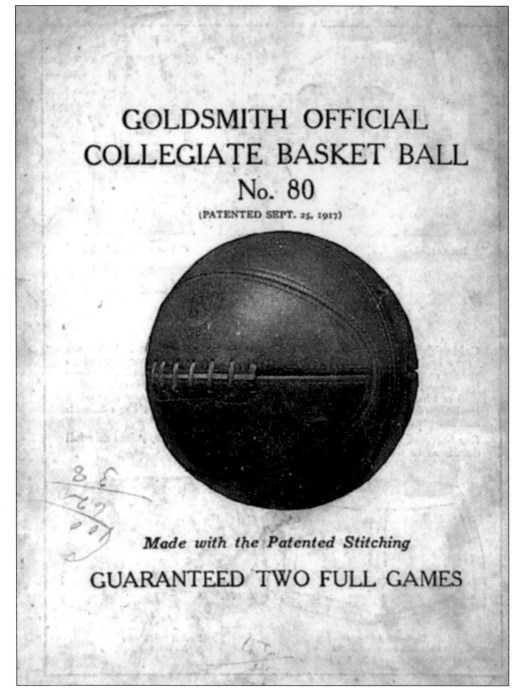

GOLDSMITH OFFICIAL COLLEGIATE BASKET BALL
No. 80
(PATENTED SEPT. 25, 1917)

Made with the Patented Stitching

GUARANTEED TWO FULL GAMES

Cincinnati's Goldsmith Sporting Goods Company was the city's major manufacturer and supplier of athletic equipment from the early 1900s to World War II, marketing everything from boxing gloves and baseball bats to football helmets and fencing gear. This catalog showcased their basketball equipment, especially the "official collegiate basket ball no. 80." The meager two full-game guarantee that came with the ball suggests that the game was being played a great deal rougher than one would imagine!

The L.B. Harrison Club was founded in downtown Cincinnati in 1914 as a residential hotel and club for young businessmen, a place where they could participate in athletics and cultural activities, and live in a wholesome environment. After a gymnasium was added in 1917, the Harrison Club asserted itself as a force in local athletics, all under the stern eye of its director, W.O. "Doc" Rakestraw. Rakestraw came to the Harrison with a devotion to clean living and sports. The gym was equipped with the standard parallel bars, medicine balls, and Indian clubs, but Rakestraw wanted sports teams as well. He regularly scouted nearby colleges to recruit basketball players to live at the Harrison after graduation. In 1922, the LBH team won the city basketball championship for the fifth time in seven years. Rakestraw was a blunt and stern disciplinarian: his printed rule book included "Have your gym suit washed once in a while" and "Fellows addicted to the drink habit are not wanted. Sounds plain, doesn't it?"

Boyd Chambers served as the UC basketball coach from 1918 to 1928, building a record of 106-81. His best year was the 1925-26 season when the Bearcats were 17-2, winning the Buckeye Athletic Association Championship. Chambers was also the first man to hold the official title of "Athletic Director" for UC. Chambers was equally well known in southwestern Ohio for the annual Tri-State Basketball Tournament he ran in the 1920s, inviting the best high school squads in the area to compete at the university's gym.

The_____school basketball team intends to participate in the Tri-State Basketball tournament to be held at the University of Cincinnati, February 18th and 19th, 1921.

PRINCIPAL

NOTE: Please return this card at the earliest possible date.

BOYD B. CHAMBERS,
Athletic Director
University of Cincinnati.

Sixth man Bearcat William Baildon played for the University of Cincinnati during the 1922-23 season. He lettered that year backing up guards Albert Ernst and Harry Hacken as the team compiled a record of 13-9. Here he poses outdoors, his uniform showing part of the standing, growling Bearcat mascot in use then.

Pictured here is an early scorecard for a match up at UC's Schmidlapp Gymnasium, or the "Men's Gym" (the "women's gym" was located in the "women's building," Beecher Hall). The Bearcats won this game against archrival Miami by a score of 38-25.

Miami University
vs
University of Cincinnati

Men's Gym - Saturday, March 5, 1921

	CINCINNATI				MIAMI	
Score	Player	No.	Position	No.	Player	Score
___	Coons Capt.	3	F.	4	Moore Capt.	___
___	Williams	12	F.	1	Mildners	___
___	Linneman	10	C.	16	Wolf	___
___	Schierloh	1	G.	2	Wire	___
___	Irwin	4	G.	3	Wright	___
___	Geis	11		7	Davis	___
___	Hibarger	9		6	Heeter	___
___	Van Pelt	2		8	Somdahl	___
___	Ernst	7				
___	Steele	6				
___	Osbourne	8				

Referee, Prugh - - Time Keeper, Gabriel
Umpire, Reese

Last Game of Season, here. Sat., March 12, 1921. Dennison
DANCING AFTER THE GAME

EASTER STATIONERY AND GREETING CARDS

The Macey-Hall Company
548 MAIN STREET

In 1921, players trying out for the University of Cincinnati basketball squad had to sign a pledge to obey the training rules that included abstention from alcohol, tobacco, and late nights. Some players added a touch of humor to the pledge by signing the names of boxing champions Benny Leonard and Jack Dempsey and former presidents Warren G. Harding and William Howard Taft. Presumably, Taft set the picks, Harding set the odds, and Leonard and Dempsey set upon the opposition.

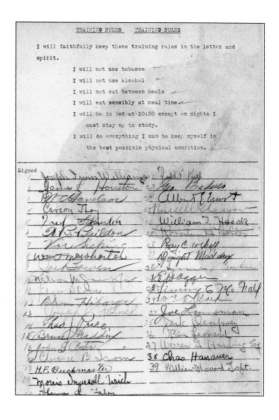

The first big man to play for the Bearcats was 6-foot 8 1/2-inch center Charles Sims in the 1922-23 campaign. Sims was an engineering student whose only basketball experience was limited to the noontime games during the engineering college's "Hobby Hour," an innovation that the dean, Herman Schneider, brought about. During Hobby Hour, students could do anything *but* concentrate on studies, to allow them to become well-rounded students. Sims's standing reach was nine feet, so he was used primarily to park under the opponents' basket and smack away the ball. Before the opening game with Antioch that year, Sims posed with a push ball. UC only won by a score of 24-22, so apparently Sims missed a few shots flying through the air.

33

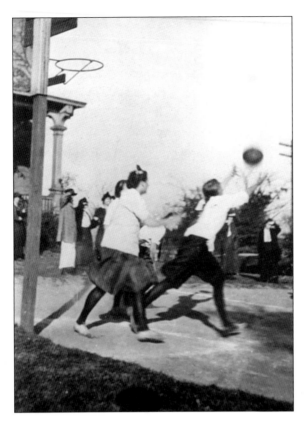

By the 1920s, women's competitive basketball was seen increasingly as unfeminine and dangerous to the traditional roles of housewife and mother. Intercollegiate and interscholastic ball on the university and high school levels could lead, it was thought, to sweating, swearing, and even barrenness. More proper, the reasoning went, were intramural games in which travel and hot rivalries were not involved. In the top photo, two girls' teams from Seven Hills School play an outdoor game, while in the bottom cartoon from a UC student newspaper, the illustration shows an impression of how rough the women's game was becoming.

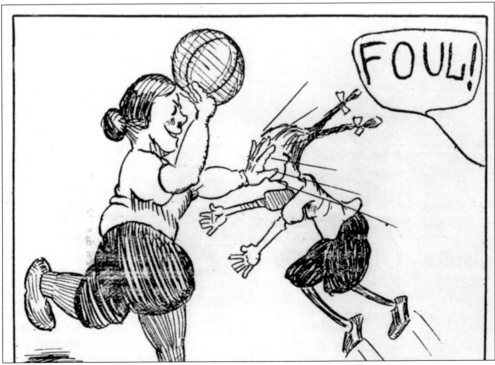

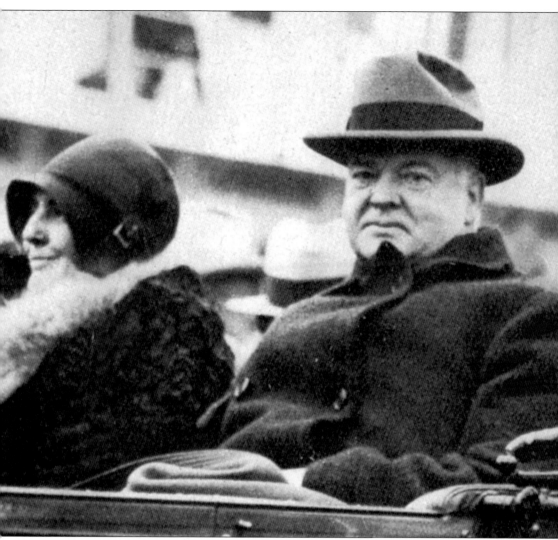

The anti-competition movement had a national advocate in Lou Henry Hoover, wife of Herbert Hoover (pictured here with her husband during a 1929 visit to Cincinnati). Mrs. Hoover was a highly educated woman who headed the Girl Scouts of America and helped found the Women's Division of the National Amateur Athletic Foundation. She firmly believed that female participation in sports helped build character, but she was opposed to intense competition, particularly in basketball, believing that such strenuous activity was not only damaging to girls, but prevented many other girls from participating in athletics.

Two Cincinnati educators who followed Lou Henry Hoover's thinking were Helen Norman Smith and Helen L. Coops at the University of Cincinnati. Smith succeeded Marjorie Hillas as women's basketball coach at UC in 1922, and immediately brought a different philosophy to the sport than that of the fiery Hillas, who wanted the game for women to be on a par with that of the men's. Over three seasons, Smith's teams had a record of 11-3-1, but by 1925 intercollegiate competition was over. Both Smith and Coops taught in the college of education, from where they ran the women's athletic programs, and like other educators around the country, formed organized "Play Days" of intramural competition and rhythmic dance, believing more coeds could be included in sports this way. Over the years, they wrote a number of academic papers and practical manuals on women's athletics. By 1930, competitive intercollegiate basketball for women was dead.

THREE

The Great Depression and the War Years 1931–1952

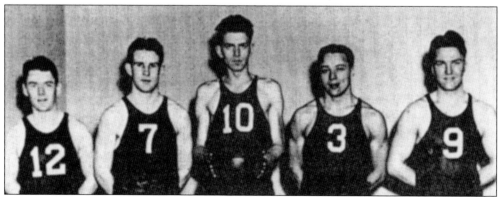

The 1939 Cincinnati Redlegs was another of the city's barnstorming teams. Comprised of former Xavier University and University of Cincinnati athletes, the team played mainly in Ohio, Indiana, Michigan, and Pennsylvania. Pictured from left to right are Leo Sack, Russell Sweeney, Carl Austing, John Wiethe, and Clark Ballard. Sack also played for another early pro team, the London Bobbys, and Ballard and Wiethe became basketball coaches for the UC Bearcats.

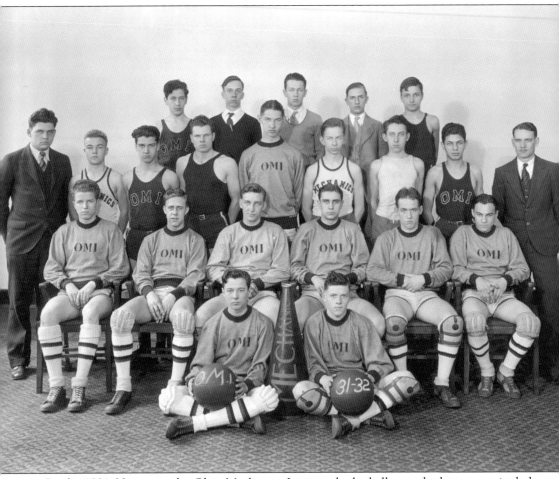

By the 1931-32 season, the Ohio Mechanics Institute basketball team had grown to include thirteen players, three student managers, and four cheerleaders. The team was coached by Carl McFarlane, who not only ran the basketball program, but also coached the baseball team and taught English. OMI's record that year was 9-8; Louis Bok took the scoring honors with a 6.7 average. OMI was a technical school that drew students of high school age as well as older ones seeking education beyond a secondary school degree, so their athletic competition was usually composed of high schools, junior varsities, and community teams.

Chester Smith was the first African-American member of the University of Cincinnati basketball team, playing from 1931 to 1934. Smith was a well-rounded athlete, starring on the football and track teams as well. For the hardcourt Bearcats, Smith played forward his junior year, and center when he was a senior. He was also the first African-American athlete at UC to be given financial assistance from the athletic department to play ball.

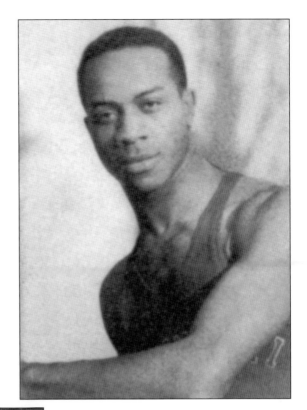

Carl Austing was an outstanding Bearcat from 1933 to 1935, piling up 256 points his junior year and 222 during his senior season when he also captained the team. In the Buckeye Conference, he was named to the All-Star and All-Ohio teams, and led the league in scoring. Following his collegiate career, Austing played for the barnstorming Redlegs, and in 1985, at the age of 74, his Senior Olympics basketball team won the Ohio title.

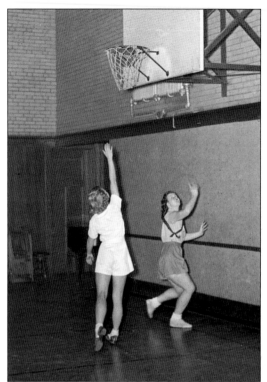

By the years of the Great Depression, if UC women wanted to play basketball, it was typically done through a physical education program in Teachers College, the university's college of education. Professors served as coaches for women's sports, and nearly all competition was intramural in nature. Very occasionally, teams from Miami or Dayton would play the UC teams, but the games would never count in a league or conference structure. However, rules against intercollegiate play could not mask the intense competitive nature of the women when they took to the court.

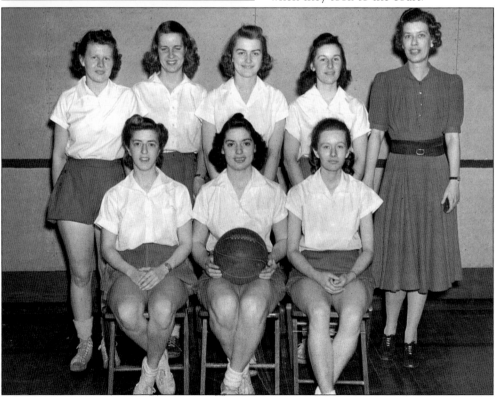

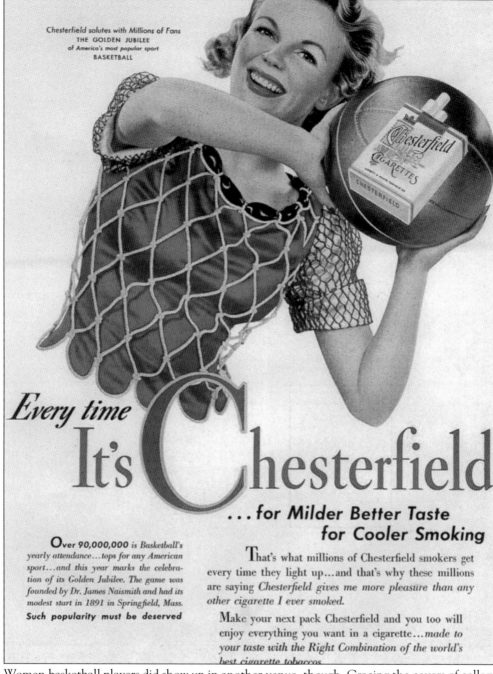

Women basketball players did show up in another venue, though. Gracing the covers of college basketball programs around the country in 1941 was a beautiful coed draped in a basketball net and holding a ball with the product—Chesterfield Cigarettes. The 1941 Golden Jubilee of Naismith's invention was used by Chesterfield to market their product to the 90 million fans who enjoyed basketball every year. The pleasure basketball brought these millions of people, Chesterfield asserted, would find pleasure as well in their cigarettes. This image is from a University of Cincinnati basketball program.

41

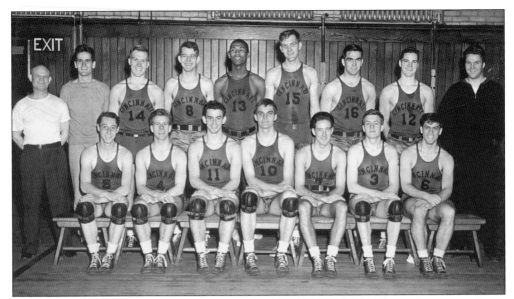

The 1942 University of Cincinnati basketball team had its third African-American player, Willard Stargel. Stargel was preceded by the second Black player, London Gant, a reserve on the '35-36 squad. Also featuring Captain Ellis "Butterbutt" King, the '41-42 Cagers went an even 10-10 under Coach Clark Ballard, an alum of the pro Redlegs and of the '33-35 Bearcat basketball teams. Following the season, Stargel enlisted in the army. After World War II, he came back to UC on the G.I. Bill, earned his diploma, and became a notable teacher and coach in the Cincinnati public schools.

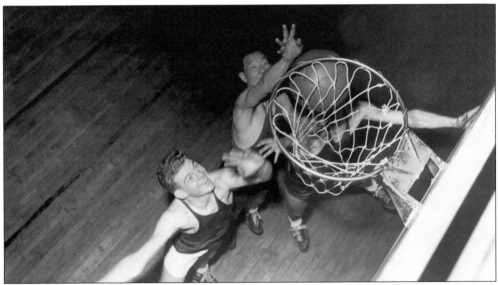

College sports were greatly diminished during World War II as the nation's university students helped fill the military ranks. Many schools discontinued football, but kept basketball alive because it required fewer players and less equipment. At the University of Cincinnati, it also allowed a new face: Masaru Nishibayashi, a Japanese American from Los Angeles who had been interned with his family in an Arkansas relocation camp. He was permitted to enroll at UC in 1943, becoming the only Asian-American basketball player the school has ever had.

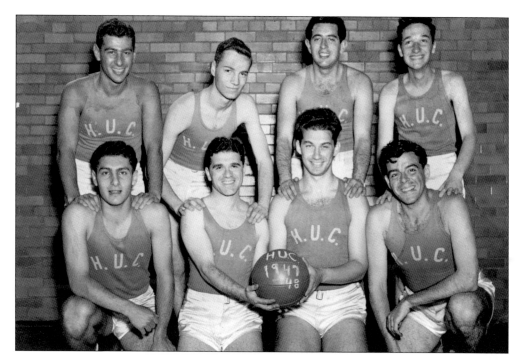

The Hebrew Union College teams in the 1940s continued their schedules against local club and YMCA teams, and sometimes even took on alumni teams from HUC. During this time, the HUC hoopsters were one of six Cincinnati college squads, joining UC, XU, the Conservatory of Music, the College of Music, and the Ohio Mechanics Institute. (Photos courtesy of the American Jewish Archives.)

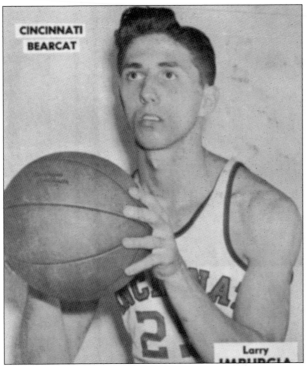

CINCINNATI BEARCAT

Larry IMBURGIA

Larry Imburgia, a forward for the UC Bearcats from 1950 to 1953, overcame childhood polio to build a solid one-hand shot. Even though he was a reserve in the 1950-51 year in which the 'Cats went 18-4, won the Mid-American Conference Championship and went to the National Invitational Tournament, Imburgia led the team with a 24.2 points per game average.

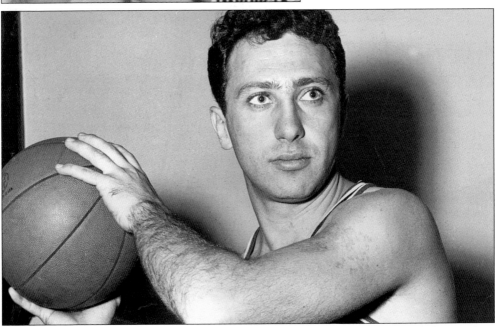

New Yorker Al "Rabbit" Rubenstein was one of John "Socko" Wiethe's first solid players when he took over as UC coach in 1946. Rubenstein was a four-year starter at guard, and finished just short of the 1000-point club with 987, a 10.1 per game average. During the late 1940s, Wiethe used military vets like Rubenstein, Jack "Black Cat" Laub, and Ralph Richter to build UC into a national power, and to start scheduling the Bearcats in New York's Madison Square Garden against top teams.

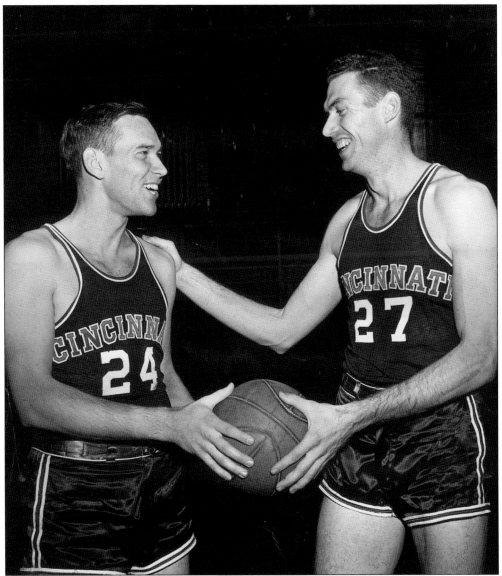

Dick Dallmer (left) and Bill Westerfield (right) were the University of Cincinnati co-captains for the 1948-49 season, guiding the team to a 23-5 mark. Local sportswriters called that squad the greatest UC team to that time. Dallmer earned Honorable Mention All-America honors, and along with teammate Ralph Richter initiated UC's 1000-point club. Dallmer finished his career with 1098 points, and Richter had 1053. Through the 2002-2003 season, thirty-nine Bearcats had scored more than 1000 points.

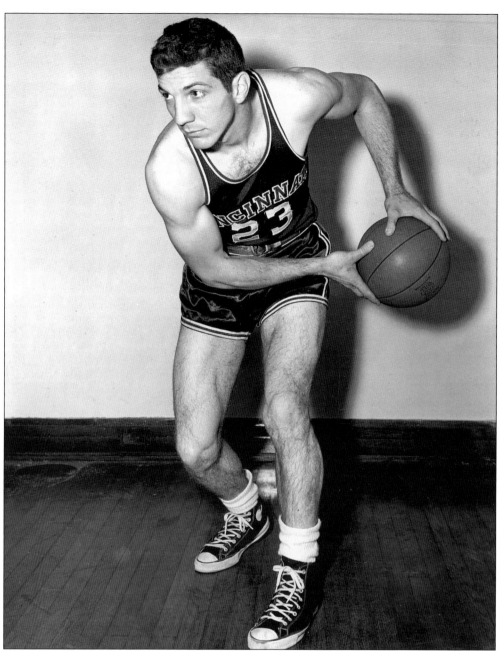

Jumpin' Joe Luchi, another Wiethe star, was known for his high-flying moves to the hoop. His strong defensive play led the Bearcats to the third and fourth of Coach Wiethe's five consecutive Mid-American Conference titles. Luchi was also the third of four players to complete their eligibility under Wiethe who were drafted by the NBA: Dick Dallmer by the Philadelphia Warriors and Jack Laub by the Baltimore Bullets in 1950, Luchi by the New York Knicks in '51, and Jim Holstein by the Minneapolis Lakers in '52. Holstein was also a thousand-pointer with 1146.

By the end of World War II, the games between the University of Cincinnati and crosstown rival Xavier University were some of the hottest on the schedule. During a contest in the Cincinnati Invitational held at the Gardens, Luchi goes for a lay up as Xavier's Bill Cady watches him soar. The 'Cats won, 59-48. World War II caused a different interpretation of eligibility rules in college sports. The military vets came back to college, and in some cases were allowed to start their eligibility anew. Bearcat Laub, for instance, was a City College of New York transfer and a vet, and compiled six years of varsity play.

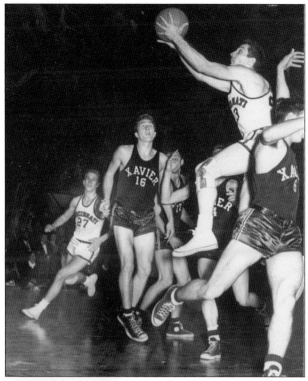

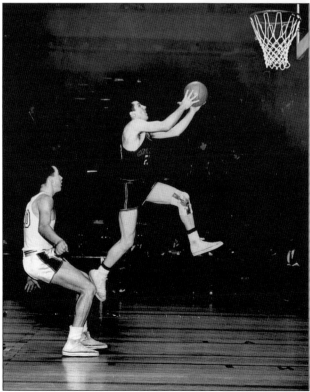

Jumpin' Joe takes to the air again, this time in a National Invitational Tournament game in New York's Madison Square Garden. Facing up against a strong St. Bonaventure team on March 11, 1951, UC lost to the Bonnies, 70-67, in two overtimes.

Not everything was going well with the UC basketball program, however. It was becoming more difficult to schedule games against quality opponents in the campus's bandbox gym. In 1946, a shady "promoter" out of New York by the name of Sam Feinberg appeared in Cincinnati to stage UC and Xavier games at Music Hall Sports Arena. XU declined. Without checking Feinberg's background, Bearcat athletic director Chic Mileham allowed him to handle game promotions. Soon Feinberg was deep in debt and unable to pay bills and guarantees to various teams. Worse, he had reportedly recruited Laub and Rubenstein to play for Wiethe and then tried to fix games by asking them to shave points. Investigations into the integrity of college basketball games began throughout the country and it was revealed that Feinberg's brother Saul bribed University of Kentucky player Dale Barnstable to throw a game. Feinberg was held as a material witness in the investigations. In February 1949, UC cut ties with him and switched home games from Music Hall to Cincinnati Gardens.

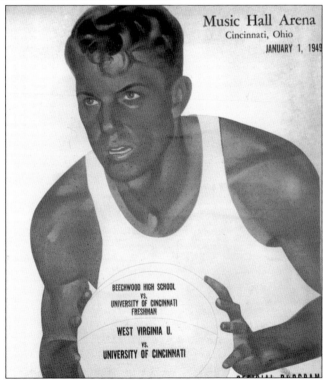

Music Hall Arena
Cincinnati, Ohio
JANUARY 1, 1949

BEECHWOOD HIGH SCHOOL
VS.
UNIVERSITY OF CINCINNATI
FRESHMAN

WEST VIRGINIA U.
VS.
UNIVERSITY OF CINCINNATI

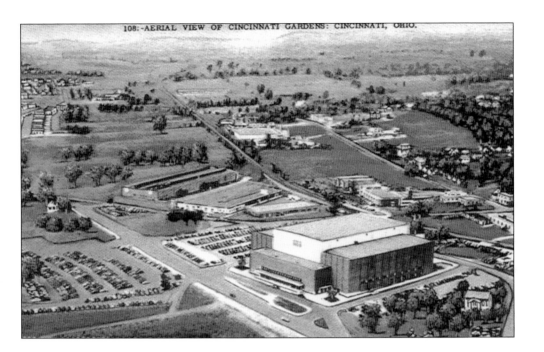

The decision to break with Music Hall came at a fortuitous time because the Gardens had just opened. Constructed in the outlying neighborhood of Bond Hill, the Cincinnati Gardens was ostensibly built for hockey, and it opened on February 22, 1949 with a match between hockey teams from Montreal and Dallas. The next night, however, the Gardens hosted its first basketball game as UC bested Butler, 49-44. And, the night following that, Xavier played its first game there, losing to Kentucky, 51-40. They drew over 13,000 fans as Muskie Bill Cady tossed in 17 points. Over the next thirty years, the Gardens would become the basketball *Mecca* for Cincinnati as it became home to UC, XU, high school basketball match-ups, and the home court for the Cincinnati Royals.

The center of the college basketball universe, though, was Madison Square Garden in New York City. The site's popularity began when Garden promoter Ned Irish began staging college doubleheaders in the 1940s. With the development of the point spread at about the same time, college hoops skyrocketed in popularity. So did point shaving. Two New York schools, City College of New York and Long Island University, would be involved the most in the scandals that erupted in 1950 and 1951. On February 23, 1950 the Bearcats played the LIU Blackbirds, who were 11-point favorites. The 'Cats "upset" them, 83-65. The game became part of the legal evidence for the criminal investigations of gamblers and players in which LIU's Eddie Gard and its national star, Sherman White (#20 in this photo of the LIU-UC game) were convicted. In the end, games were fixed in 22 cities in 17 states; 33 players form six colleges were involved. And this was only what came to public light.

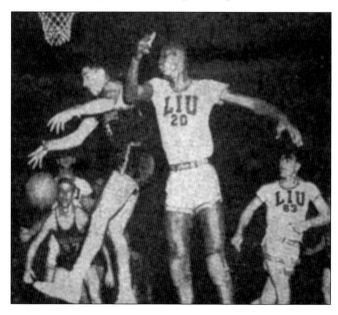

FOUR

A Professional Team and College Championships 1953–1964

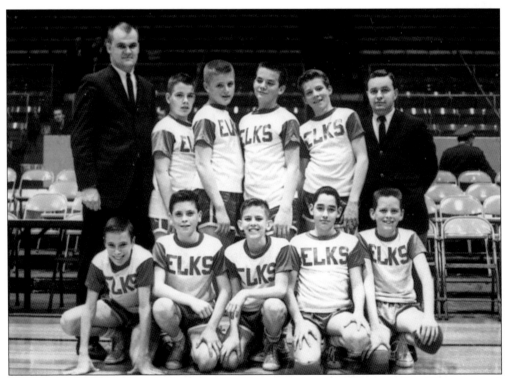

As part of their community involvement, the Cincinnati Royals sponsored a Pee Wee team, and often held clinics at the Gardens for local youth teams, inviting some of them to play during halftime of the pro games. In 1963, a young team of "Elks" gather for a group shot along the court.

Ike Hyams was "King of the Bookies" in Cincinnati during the 1940s and '50s, and although he favored horseracing, boxing, and baseball, the point spread for college basketball games made them an attractive sport for betting action. Hyams ran his operations out of bars and cigar stores he owned along Vine Street in Elmwood Place, such as the Linden Bar, the Maple Club, and the Valley Cigar Store. Like bookmakers across the nation, he subscribed to the so-called "Minneapolis Line," a wire betting service that provided the spreads. But Hyams was more than a businessman bookie. He was also a Hamilton County Republican stalwart and a strong supporter of the city's amateur athletic programs.

Valley

CIGAR STORE

ALL SPORTING
EVENTS BY WIRE
AND
SPEAKER SERVICE

6117 VINE STREET
ELMWOOD, OHIO

Phone Valley 9817

A 1952 newspaper cartoon by George Bristol of the *Times-Star* shows how versatile the sports events were at the Cincinnati Gardens. On the exterior of the building, relief sculptures of hockey, boxing and, and basketball figures graced the walls. Inside during any given week during the winter, sports fans could see a hockey game, a local boxing match, a high school hoops contest, or XU and UC tilt it up against teams from around the country. By the arrival of the Royals in 1957, the Gardens was established as the sports palace of Cincinnati.

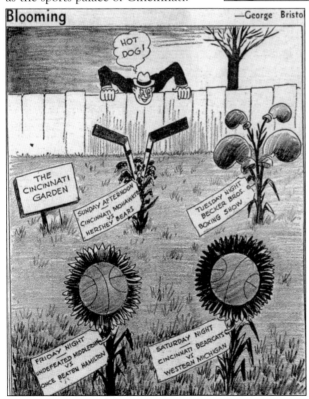

George Bristol drew his sports cartoons for the *Cincinnati Times-Star* for 35 years, beginning in 1923. As shown in these two basketball sketches from 1954, much of his work appeared on the day of events as a preview to the night's action, playing upon local rivalries and building up the hype for the importance of the games. In the top cartoon, UC topped the Miami Redskins, 66-58 on February 6, and four days later, in the game touted by the bottom drawing, beat Xavier 81-76. Both games were at the Gardens. Bristol retired from the drawing board in 1958, and died in 1986 at the age of 93.

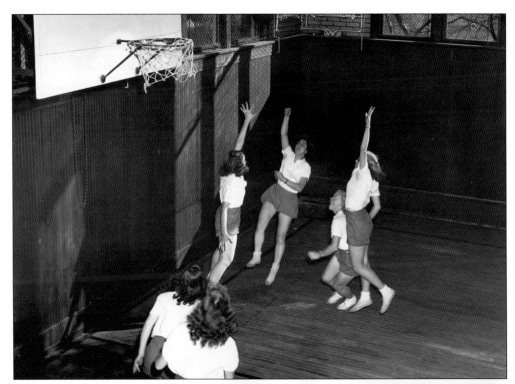

These two photos from 1952 are of women's intramural "non-competitive" basketball action in UC's Beecher Hall. Change was still twenty years away: in 1972, Title IX passed, and the Association for Intercollegiate Athletics for Women held its first intercollegiate basketball championship that same year. By 1976, women's basketball was an Olympic sport (men's basketball became an official medal sport in 1936). Eventually these changes enfranchised girls and women in fully participating in the game again. Locally, Title IX's influence allowed a college coach like UC's Laurie Pirtle to step up and recruit better players, and a high school coach like Mary Jo Huismann to begin the first summer league for girls.

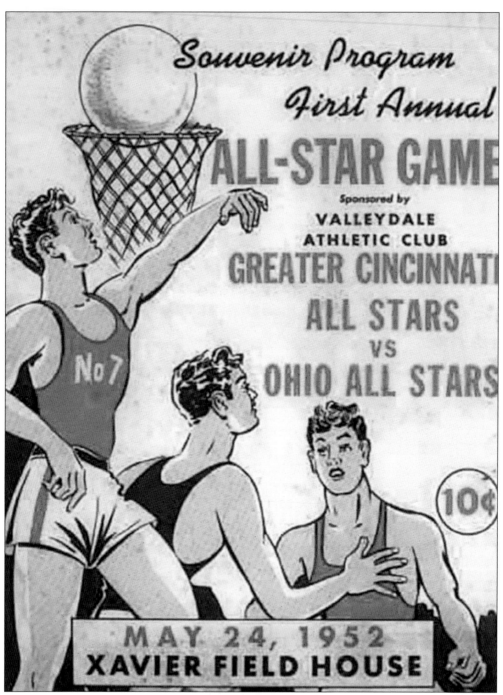

Souvenir Program
First Annual

ALL-STAR GAME

Sponsored by

VALLEYDALE ATHLETIC CLUB

GREATER CINCINNATI ALL STARS

VS

OHIO ALL STARS

No 7

10¢

MAY 24, 1952
XAVIER FIELD HOUSE

On May 24, 1952, Xavier University's Schmidt Fieldhouse was the venue for an all-star game pitting local hoops stars against an Ohio-wide team. By the 1950s, and into the 1960s, Schmidt was often used for high school basketball, as well as for the XU Musketeers. Built in 1928 at a cost of $325,000 and named for Walter Schmidt, the XU alum who contributed the funds, Schmidt Fieldhouse had an auspicious dedication. On March 7, Xavier and UC met for the very first time. Xavier won, 29-25, on their way to an 8-1 season.

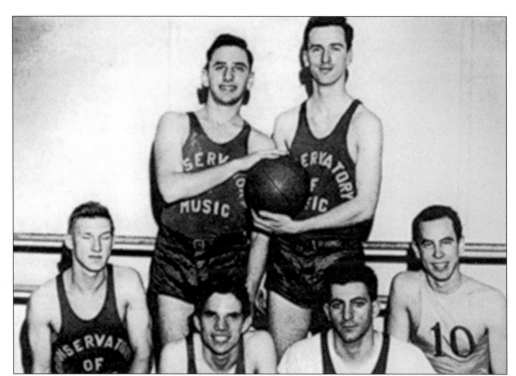

Named the "Five Sharps," the Cincinnati Conservatory of Music had a lively—and presumably a well-orchestrated—team in the 1940s and 1950s before the Conservatory merged with the Cincinnati College of Music. The school played its games at the Williams YMCA in Walnut Hills, claiming several tournament championships along the way. This '51 squad was coached by George Sarabolis and reeled off five straight wins before injuries led to a final 8-5 record.

The College of Music also fielded a basketball team, and after the Conservatory and the College merged in 1955, games became intramural affairs between degree programs, the Radio-TV Department taking on an orchestral department, for instance. Appropriately, several games were played on the Music Hall court. In 1962, the College-Conservatory of Music became a college of the University of Cincinnati.

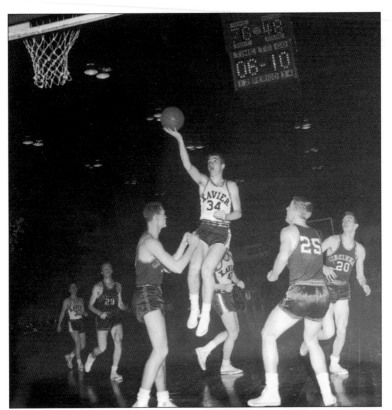

In the first of two games between Xavier and Cincinnati in the 1956-57 season, XU's Hank Stein elevates for a lay-up during the January 9 game at the Gardens. Xavier won, 88-62. Stein had great years for the Muskies from 1956 to 1959. He scored 1,144 points during his varsity career.

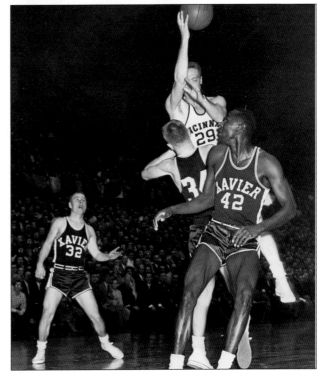

The second match-up between the schools came on February 13 at UC's Armory Fieldhouse. UC prevailed this time, 69-57. Watching a Bearcat make contact in a drive to the basket is Xavier's Jim Booth, #32. Boothe was another thousand-pointer for XU, scoring 1,085 points from 1954 to 1957.

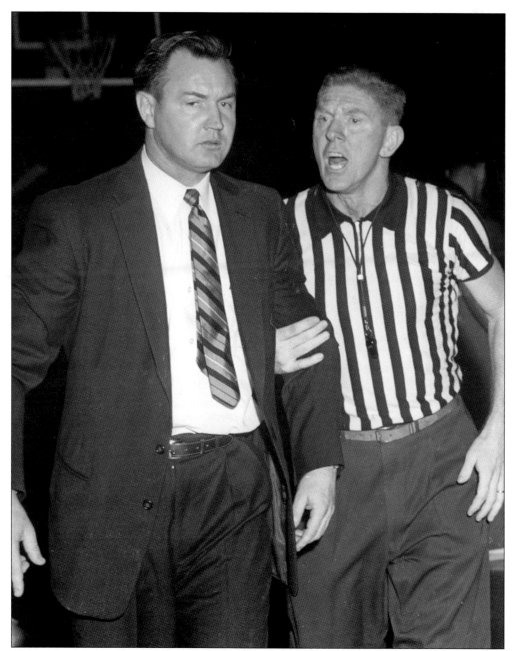

Thrust into the head coach's position in 1951 with the sudden departure of incumbent Lew Hirt just before the season started, Ned Wulk of Xavier was known for his intricate plays as much as for his fiery temper. In this photo from the 1957 NIT tourney, Wulk is led from the court after an altercation with a referee. Wulk left XU in 1958 with a record of 89-70, and headed for a long illustrious career at Arizona State University. At Xavier, he was replaced by Jim McCafferty, who promptly led the Musketeers to a surprise NIT championship in 1958 in a thrilling overtime final against Dayton, 78-74.

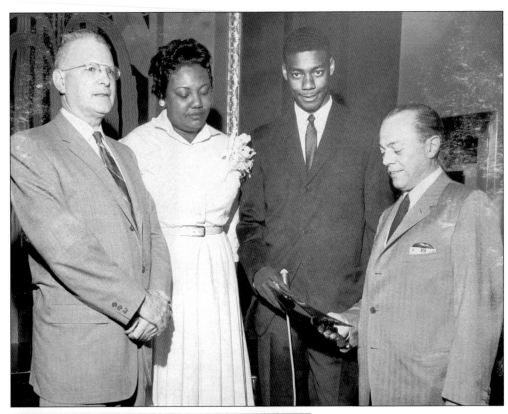

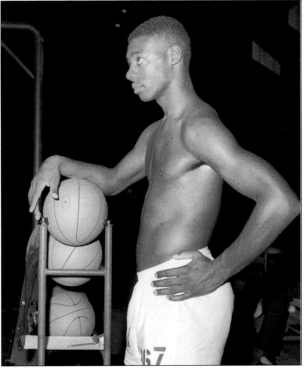

After leading Indianapolis's Crispus Attucks High School to the Indiana State Championship, Oscar Robertson was a highly-recruited schoolboy star. Robertson chose the University of Cincinnati and Coach George Smith, becoming only the fifth African-American basketball player at the school. In the top photo, he stands with his mother, UC president Walter Langsam (far left) and UC booster Ben Swartz (far right) on his arrival on campus. In the bottom image, Robertson stands at courtside, ready to begin practice. (Both photos by Jack Klumpe.)

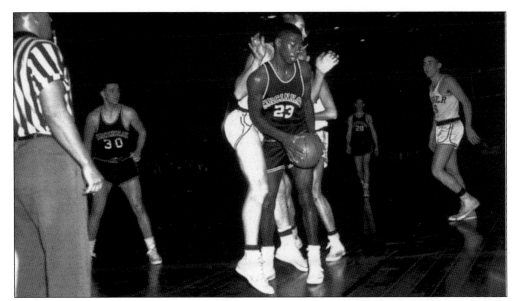

More than 75 colleges recruited Robertson out of high school, but UC was the winner and Robertson would take them to the next level beyond the solid base constructed by Socko Wiethe and his players like Dick Dallmer, Jim Holstein, Jack Twyman, Ralph Richter, and Bill Westerfeld. During his freshman year as a Cincinnati Bearkitten, Robertson wore #23 on his uniform, instead of the varsity #12, which would eventually be retired in his honor. In this photo from his 1956-57 season, Robertson handles the ball in a game against the Xavier University freshman team. In just a short time he would become forever known as "The Big O."

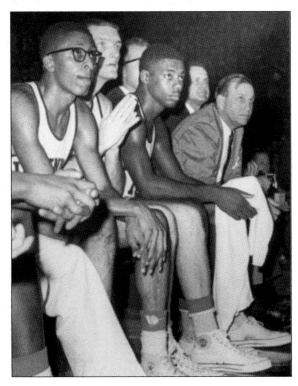

As a member of the varsity squad the next year, Robertson takes a rare rest on the bench, watching the action with teammates John Bryant and Ralph Davis, assistant coach Ed Jucker, and head coach George Smith. Robertson led the nation in scoring in 1957-'58 with 984 points, and scored over 50 points in three of the Bearcat games. He also led the team to its first NCAA tournament appearance. (Photo by Jack Klumpe.)

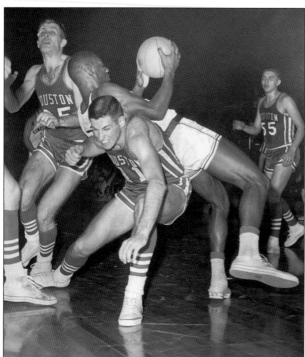

During a game against the Houston Cougars in the Armory Fieldhouse, Robertson grabs a rebound, and falls back onto a Cougar. During Robertson's three varsity years, the Bearcats were 6-0 against Houston, and his sophomore season began a streak of six consecutive Missouri Valley Conference Championships for UC. (Photo by Jack Klumpe.)

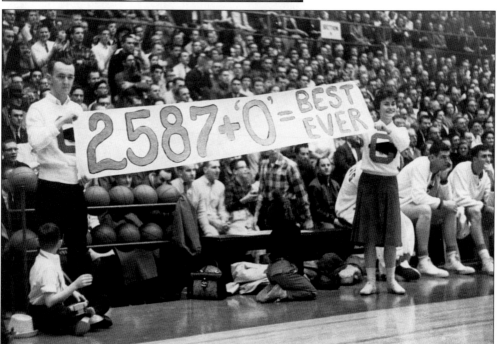

Bearcat cheerleaders unfurl a banner proclaiming that the Big O was the most prolific scorer in college hoops history. Robertson would go on to finish his UC days with an astounding 2,973 total points, this in an age when freshmen were ineligible for varsity play. In comparison, Steve Logan, the number two scorer in Bearcat history, finished his four-year varsity tenure in 2002 with 1,985 points, still almost a thousand fewer than Robertson. (Photo by Jack Klumpe.)

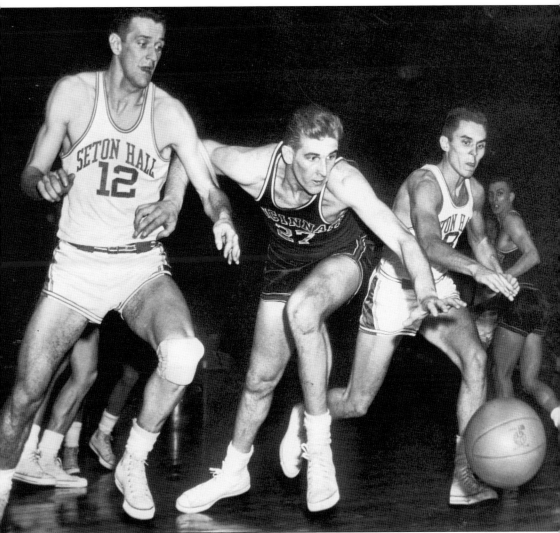

After the point shaving scandals, New York was never again the focal point for college basketball. Both CCNY and Long Island University saw their programs diminished to almost nothing, and New York's prep stars began to look farther afield than their own backyard for a chance to play college ball. Still, New York was New York, and Madison Square Garden was a choice venue for media exposure. In the 1956-57 season, UC again found itself in the Big Apple in a game against Seton Hall. In this photo, Seton Hall's Marty Farrell (#12) and Ronnie Berthasavage (#8), fight Bearcat Connie Dierking for a loose ball. UC lost the game, 80-67.

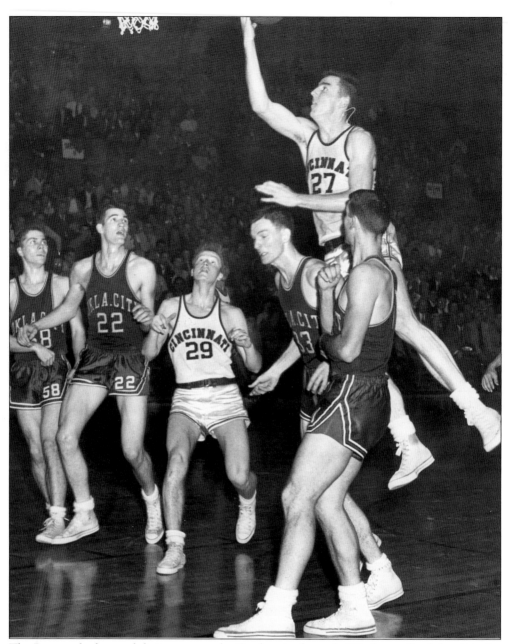

The Bearcats had moved their games to the Gardens in the early '50s, but realized that in order to keep their fan base they need a facility on their Clifton campus. Construction began on the Armory Fieldhouse in 1953, and the venue was dedicated on December 18, 1954 with a victory over Indiana University, 97-65. The Fieldhouse sat 8000 people, and at the time, with the UC program continuing to rise in the national spotlight under Coach Wiethe and star Jack Twyman, it was thought that seating was adequate. The success of the team continued to grow in the 1950s, and games continued to be played sometimes in the larger Gardens. In this photo, Twyman leaps for a lay-up against Oklahoma City College in the Armory Fieldhouse's third game, January 1, 1955, before a packed house. UC narrowly won, 68-67. Overall, the Bearcats used the Fieldhouse from 1954 to 1976, compiling a 247-29 record.

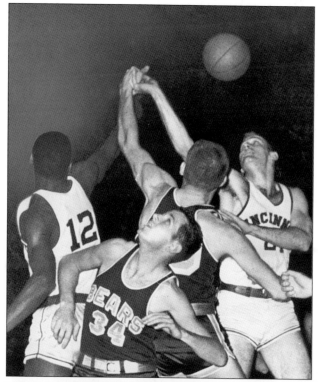

In 1959, UC made its second appearance in the NCAA tournament. Oscar Robertson was again the nation's scoring champ, and UC had a 26-4 record. In the post-season tournament, the 'Cats handily beat Texas Christian and Kansas State before coming up against the powerful Cal Bears. In these photos from that battle, Robertson and Bob Wiesenhahn battle Cal's Darrell Imhoff for a rebound, and Bob Wiesenhahn (#21) dives for the ball alongside a Bear player. Cal won the game, 64-58, and then went on to capture the national championship. UC defeated Louisville in the consolation game, 98-85, for third place.

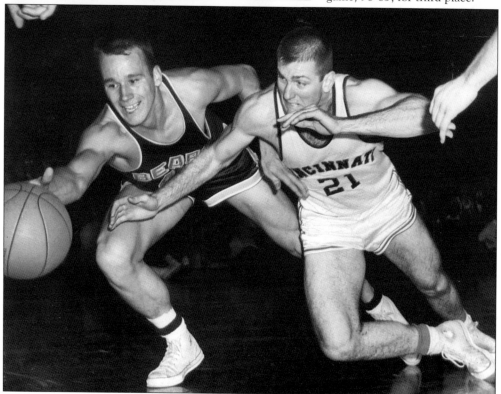

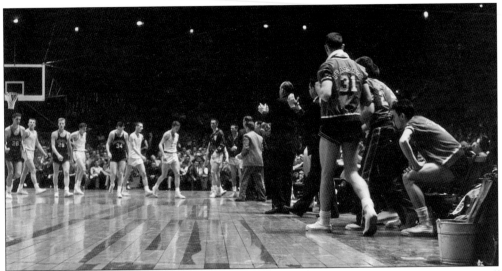

In this photo from the 1956-57 National Invitational Tournament, the Bearcats come off the floor during a timeout in their game with St. Bonaventure. The game was won by St. Bonaventure 90-72, bringing an end to a 15-9 UC season. Connie Dierking led the Bearcats in scoring that year with an 18.5 average.

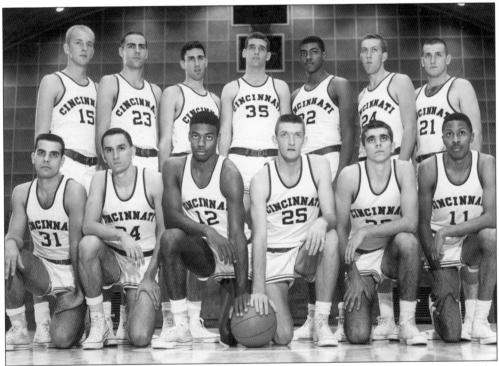

In Robertson's final varsity season, 1959-60, the Bearcats were 28-2, finishing third in the NCAA tournament and leading the nation in average scoring margin of 22 points. Pictured, bottom row, left to right are Jim Calhoun, Carl Bouldin, Oscar Robertson, Ralph Davis, Tom Sizer, and John Bryant. Back row, from left to right are Fred Dierking, Larry Willey, Sandy Pomerantz , Ron Ries, Paul Hogue, Mel Landfried, and Bob Wiesenhahn.

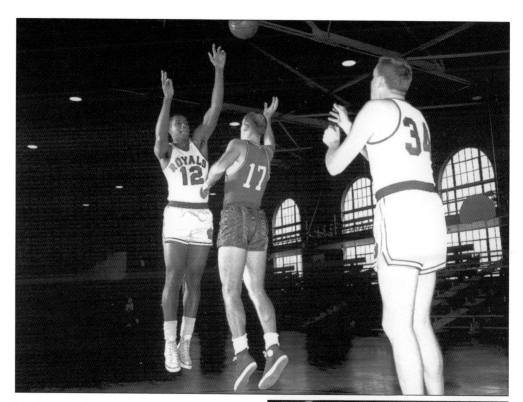

Under owner/coach Les Harrison, the Rochester Royals joined the National Basketball Association in 1948 after winning a National Basketball League title in 1946, and in 1951 the team won their only NBA championship. After an exhibition game in Cincinnati filled the Gardens, the Royals management decided on a move to the Midwest. The Royals moved to Cincinnati in 1957, but did not immediately sever all ties with upstate New York. In the '57 preseason camp in Potsdam, New York, forward Maurice Stokes rises for a jump shot.

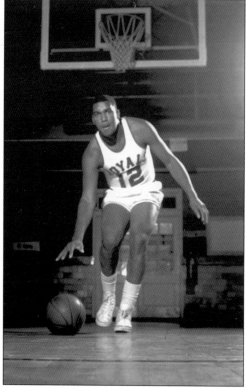

A 6-foot 7-inch power forward, Maurice Stokes was becoming one of the Royals' premier players in 1957 when they moved west from upstate New York, and was quickly becoming one of the NBA's top players. Drafted out of Saint Francis College in Pennsylvania in 1955, Stokes averaged 17 rebounds per game over the next three seasons, and consistently scored 16 points per game. Teamed with Jack Twyman in the front court, Stokes was poised to forge a strong, competitive team in Cincinnati.

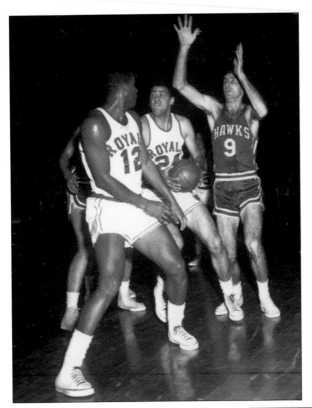

Stokes is shown here, clearing the lane for a Royal drive to the basket during a '57 game against the St. Louis Hawks in the Cincinnati Gardens. In their attempts to build championship teams in the 1950s and early 1960s, the Royals had a core of outstanding players that included Clyde Lovellette and Sihugo Green. But mediocre coaching held them back, as did the dynasties of the George Mikan-Minneapolis Lakers and the Bill Russell-Boston Celtics. In 1958, Harrison sold the team to local investors and the hope in Cincinnati—with the Royals eye on Oscar Robertson—was that Twyman and Stokes could carry them until the Big O was available.

In a 1957 game against the New York Knicks, Stokes (#12) moves into position to block a lay-up, as Jack Twyman (#27) trails the play. But later that season a tragic accident happened, and '57-58 would be his last year as a basketball player. On March 12, 1958, the Royals were playing their final game of the season against the Lakers when Stokes leaped high for a rebound and fell hard to the court, striking his head. He left the game, but felt prepared to battle thePistons when the playoffs began three days later. (Photo by Jack Klumpe.)

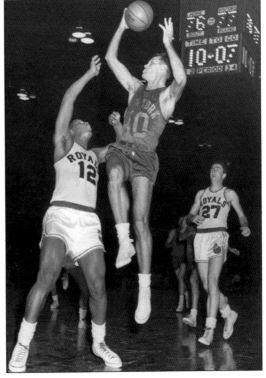

On the plane ride home, Stokes had trouble breathing, and went into convulsions. When the plane landed, he was rushed to the hospital immediately. His fall against the Lakers had caused post-traumatic encephalopathy. He was paralyzed. He couldn't speak. Maurice Stokes would never play again. At a time when players had little insurance or benefits, finances for Stokes's rehabilitation were an instant concern. Twyman, his friend and teammate, stepped forward. Twyman became his legal guardian, and spent years raising money through benefit all-star games that drew the NBA's best players in support. The rehabilitation was long and hard, but Stokes drew upon his own strength of character and leaned upon Twyman's strength of friendship. Eventually, he regained some halting speech and could walk with aid, but on April 6, 1970 he suffered a heart attack and died. His body was taken home to Saint Francis College, where he was buried on the campus. In 1973, a feature film called *Big Mo* was made about the friendship of Twyman and Stokes.

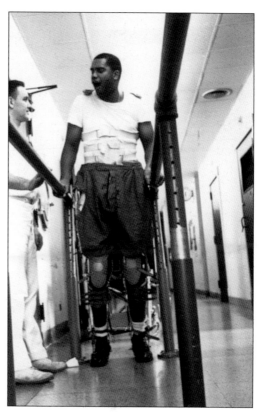

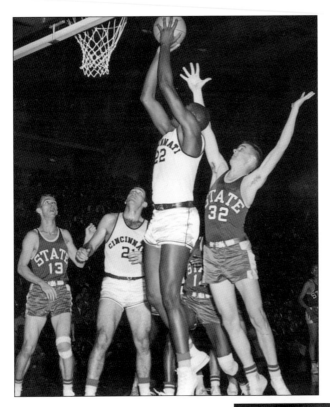

Beginning with the Bearcats' appearance in the NCAA tournament in Oscar Robertson's sophomore year, the team made extraordinary runs through their regular season schedule and into post-season play. Robertson's success at UC, achieved despite racism he faced in a number of cities on the road, was encouraging to other African-American high school players who considered the Cats. Robertson was the catalyst for attracting such players as Paul Hogue, George Wilson, and Tom Thacker. They would be

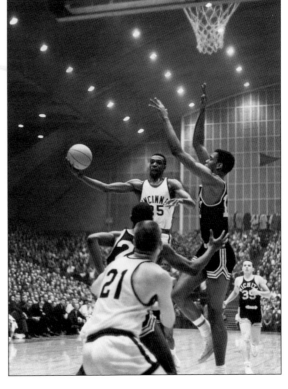

a part of taking UC over the top, from the narrow misses at the NCAA championship in '59 and '60 to the ultimate college prize in '61 and '62. In the top photo from 1960, Paul Hogue (#22) goes up for a basket in a 107-62 win over Indiana State as teammate Bob Wiesenhahn watches. In the bottom image, taken two years later, in UC's second championship year, Tom Thacker maneuvers around the Wichita State defense for a basket in an 84-63 victory.

A key player in the Bearcats' great years in the early 1960s was Ron Bonham. Bonham is the sixth leading scorer in UC history, and in 1964, he was drafted by the Boston Celtics. He played on two championship teams with the Celts, and then jumped to the American Basketball Association and the Indiana Pacers.

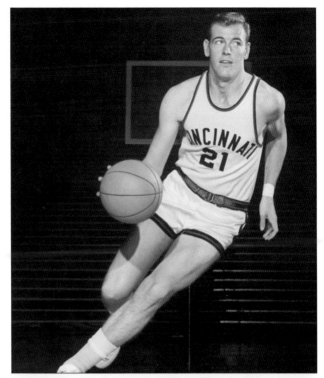

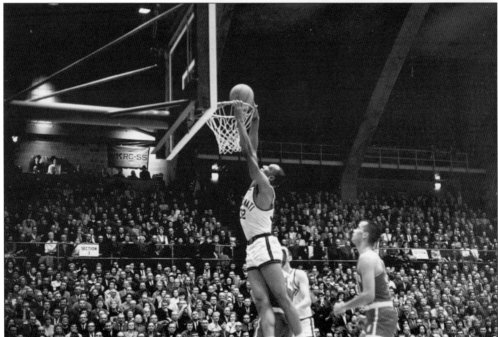

In 1964, Bearcat George Wilson goes up for a tip-in before the Fieldhouse crowd. Wilson was another player who came to UC because of Robertson, and would be a member of the second championship team in 1962. Wilson followed Robertson in the international arena as well, competing on the United States Olympic basketball team in 1964, as Robertson had done in 1960.

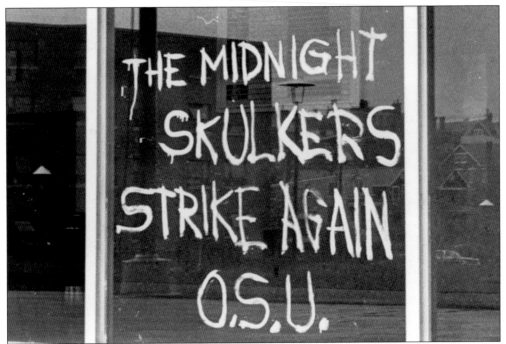

On the eve of the 1961 match up between the University of Cincinnati and Ohio State University for the NCAA championship, Buckeye fans slinked down from Columbus in the dead of night to spread a little propaganda on the UC campus. They painted their slogans on the entrance to the Armory Fieldhouse. It did them no good: the Bearcats settled their hash.

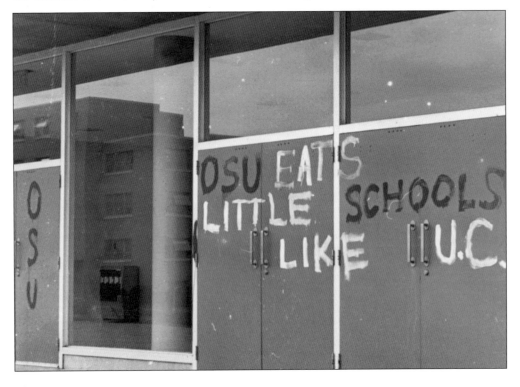

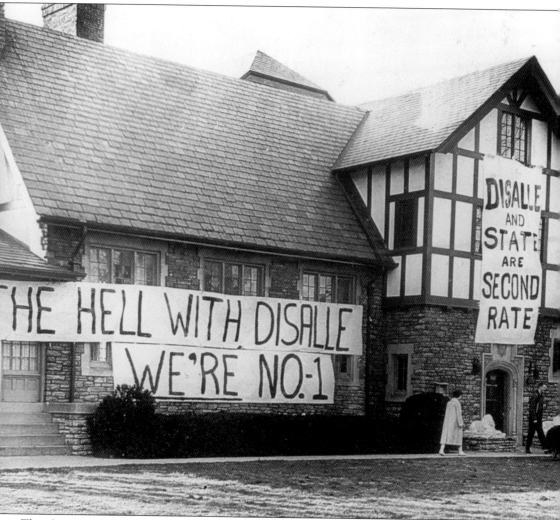

The Sigma Alpha Epsilon fraternity at UC also took exception to another Columbus resident—Ohio governor Michael DiSalle. DiSalle made no bones about the fact that he was an Ohio State backer and blithely predicted a Buckeye championship, so the frat boys went to work. DiSalle would be forced to eat crow, but it isn't known if he got the other message: the huge banners on Clifton Avenue across from the university were in very plain view to any voter who motored by. (Photo by Jack Klumpe.)

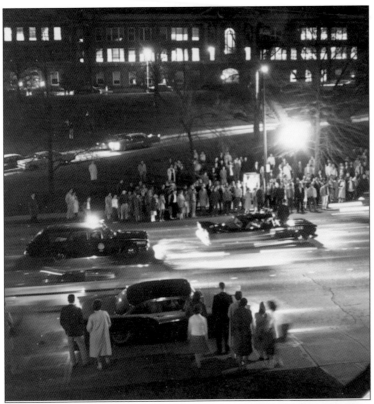

When the team returned home to Cincinnati, a cheering crowd welcomed them in the fieldhouse. In the bottom photo, Jucker and Tom Thacker lead Paul Hogue, carrying the trophy. Cincinnati mayor Eugene Ruehlmann can be seen trailing Hogue.

The 1961 battle between the University of Cincinnati Bearcats and the Ohio State Buckeyes for the NCAA basketball title was more than just a championship game—it was an all-Ohio affair to establish bragging rights in a state where the Buckeyes had a long-standing football superiority, and UC wanted a measure of athletic equality on the basketball court. The Buckeyes were the defending national champions, having defeated Cal in 1960 by a score of 75-55. The Most Valuable Player in that game was OSU's Jerry Lucas, and he was back for more. Robertson had graduated, so the running offensive weapon was gone. Instead, Coach Ed Jucker instituted a smothering defense, and involved all five players in the offense. In a dramatic overtime win in Kansas City's Municipal Auditorium, the 'Cats pulled off a 70-65 upset. UC fans swarmed Clifton Avenue after the victory, celebrating throughout the night. (Photo by Jack Klumpe.)

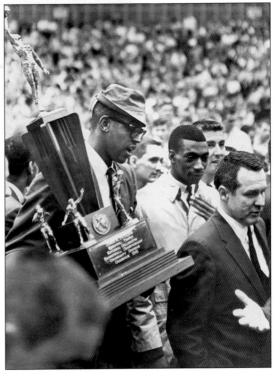

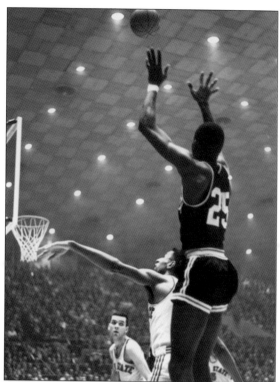

The next year was a rematch between the Ohio schools, this time with the championship game being held in nearby Louisville. Again, Jerry Lucas of the Buckeyes came in as the incumbent MVP. The polls had Ohio State atop the polls, but again, the Bearcats would hold aloft the championship trophy. Before 18,000 fans, and facing a sea of "Hate State" buttons, OSU fell to an 18-point deficit in the second half, and lost 71-59. This time, UC's Paul Hogue was the MVP, with 22 points and 19 rebounds. In the top photo, Thacker shoots a jumper as Lucas looks his way, and in the bottom photo, George Wilson skies over Lucas for a rebound.

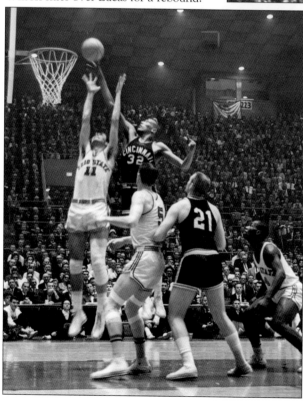

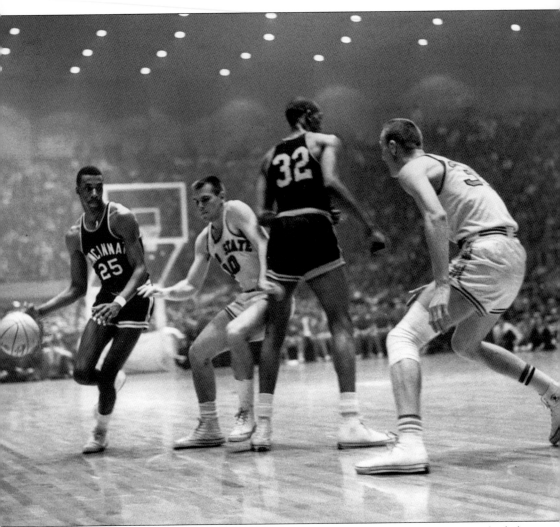

Wilson sets a pick for Thacker in the '62 championship game. The Bearcats finished their second consecutive championship year with a 29-2 record. The well-rounded offensive attack of Ron Bonham, Hogue, Wilson, and Thacker matched their strong defense. To that date, it was the most well balanced team in UC history.

Once again, on their arrival back in Cincinnati from Louisville, the Bearcats marched back into Armory Fieldhouse with another trophy, again on the shoulders of Paul Hogue. Since that '62 loss, the Bearcats have been unable to get a game with Ohio State, and in the series against them that dates to a 42-6 loss in 1905, UC is 4-4 against the Buckeyes. (Photo by Jack Klumpe.)

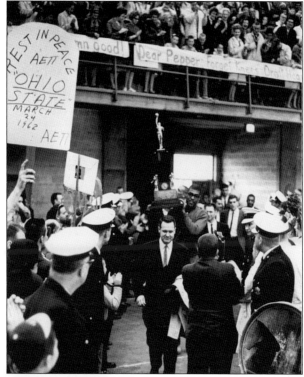

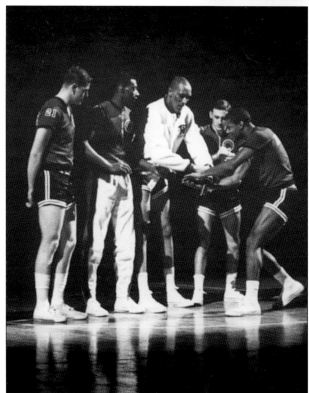

In the 1962-63 year, the Bearcats returned four starters—Ron Bonham, Tony Yates, George Wilson, and Tom Thacker, and welcomed a new fifth starter, Larry Shingleton. And this time, UC was ranked No. 1 in the national basketball polls. The team rolled through the season, racking up a 23-1 record heading into the NCAA tournament, losing only to Wichita State by one point in February. And, they had little problem with their first three opponents, Texas, Colorado, and Oregon State. In the championship game against Loyola of Chicago, they seemed to have little problem with the Ramblers, but lost a large second half lead to lose in overtime, 60-58, and ruin their dreams of a third consecutive NCAA crown. In this photo, the Bearcat starting lineup is introduced before the game.

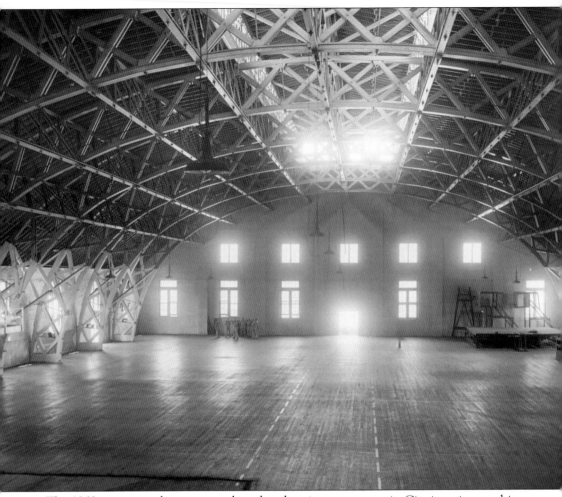

The 1960s saw an end to a venue that played an important part in Cincinnati sports history. The National Guard Armory on Freeman Avenue, in the city's West End, was designed by Samuel Hannaford & Sons, a firm that built many of Cincinnati's notable public buildings, such as City Hall. Since its 19th century construction, the Armory served as a sports arena for Cincinnatians, hosting not only the various National Guard regiments and their athletic activities, but local and national competitions as well. Bicycle races, track and field events, bowling, roller skating, boxing—they were all part of the Armory's heritage. And, so was basketball. UC played its first intercollegiate game here on December 29, 1901 when they took on a powerful Yale team, and lost 37-9. Guard regiments fielded basketball teams against local clubs like the Cincinnati Celts and the Friars Club. But by 1960, the Armory stood empty, its usefulness over. The only recent basketball games had been pickup games by the weekend soldiers. The property was sold in 1961 with thoughts of developing a merchandise mart, but that never caught on, and by 1983 it was sold again. A few years later, the Armory was demolished. (Photo by Jack Klumpe.)

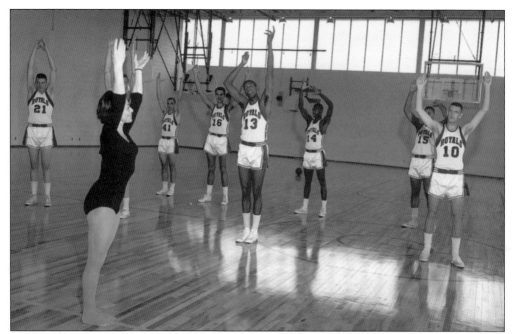

In the autumn of 1960, training camp for the Royals involved a different kind of conditioning. Local ballet teacher Anneliese von Oettingen conducted classes in movement and flexibility for the players. The German-born von Oettingen was a formidable instructor. She believed that art was inside everyone and needed to be released, and, this included the art of basketball. The Royals learned quickly: if she saw something was done incorrectly, she would not budge until it the offending player did it right.

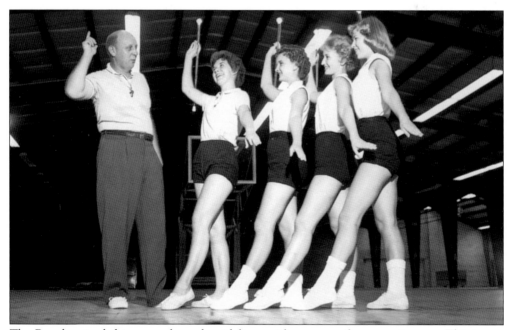

The Royals spiced things up along the sidelines with a group of team majorettes. This image shows the tryouts conducted in August, 1960.

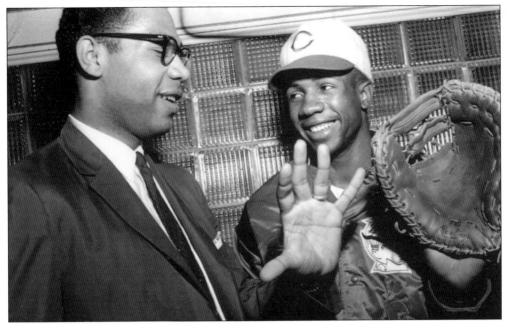

In 1961, the Royals selected Miami University's Wayne Embry in the territorial draft. That autumn, he caught up with another notable Cincinnati athlete, Reds all-star outfielder Frank Robinson to compare mitt size. Robinson clouted 37 home runs that year to lead the Reds into the World Series, and Embry did his part in helping the Royals into the NBA playoffs for '61-62, averaging 19.8 points per game. He went on to become a five-time all-star, and in 1972, Embry became the first African-American general manager when he joined the Milwaukee Bucks. He was also the first African American president of an NBA team, this time with the Cleveland Cavaliers in 1994. Five years later, Embry was elected to the Hall of Fame.

A local sports promotion in 1963 by the Cincinnati Royals allowed Reds catcher Johnny Edwards and pitcher Joe Nuxhall to try their skills at foul shots during a charity game. Nuxhall used the underhand style favored by the likes of NBA star Wilt Chamberlain. (Photo by Jack Klumpe.)

Oscar Robertson and Jack Twyman were both All-Americans at the University of Cincinnati, both had their numbers retired by UC, and both had Hall-of-Fame careers with the Cincinnati Royals. Their Bearcat beginnings were somewhat different: Twyman had little thought to enroll at UC until Socko Wiethe invited him to try out for a scholarship. Wiethe had Bearcat varsity players bang Twyman around in the old Schmidlapp Gym. Twyman banged back, Socko liked what he saw, and signed him. Robertson, on the other hand, was recruited by more than

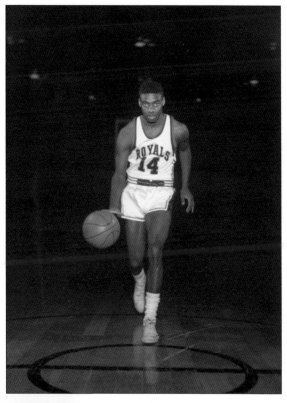

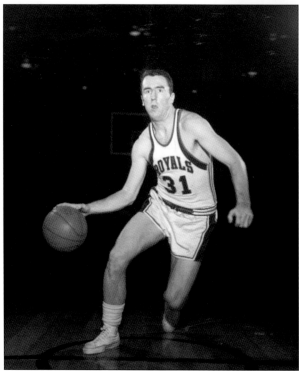

70 schools, with UC landing him. Twyman signed with the Royals when the team was still located in Rochester, and was an established star when Robertson became a Royal in 1960. Ostensibly, the Royals were vying with the Harlem Globetrotters for Robertson, and he used this competition to sign a lucrative contract to play in the NBA. But truly, there was little doubt. The NBA offered competition, and that is what drove Robertson.

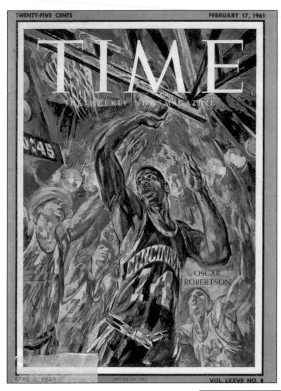

Robertson's rookie NBA year caused quite a stir. *Time Magazine* put him on the cover for its February 17, 1961 issue, calling him one of the NBA's "graceful giants." Robertson was termed as the "ideal of the complete courtman" for his considerable skills at penetrating for the shot, pulling up for a jumper, rebounding, and moving the ball down the court.

But the March 1961 issue of *Sport Magazine* that featured both Robertson and Jack Twyman on the cover, told a more complicated story about the resurgence of the Royals. There were considerable growing pains centered around Robertson, Twyman, and coach Charlie Wolf and how they learned to work together. Not since the tragic loss of Maurice Stokes had the Royals been able to build a contending team. Wolf was finally convinced that his game mix needed both Robertson's scoring and Twyman's versatile leadership if there was going to be any chance to succeed.

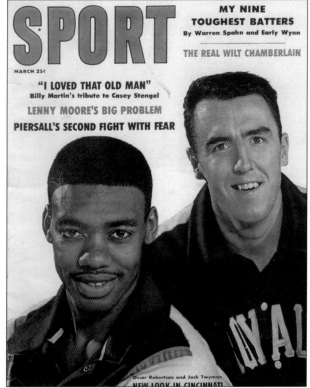

Robertson's talent in the NBA and his growing fame in American basketball prompted him to write a book in 1964 covering the elements of the game—the necessity of physical conditioning and the practicing of the fundamentals of dribbling, shooting, and rebounding. In 1997, after being named one of the 50 greatest players of all time, Robertson resurrected the basics of his early book and published a new edition in '98 called *The Art of Basketball*.

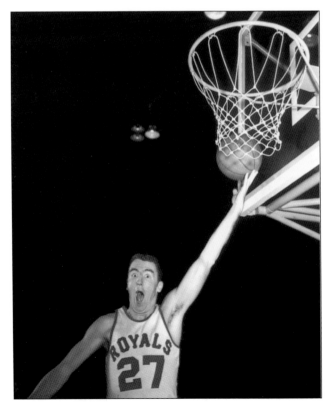

Mugging for the camera in this publicity shot, Jack Twyman eases the ball to the hoop. Twyman's steady, tenacious play had much to do with the Royals becoming a playoff contender in the early 1960s.

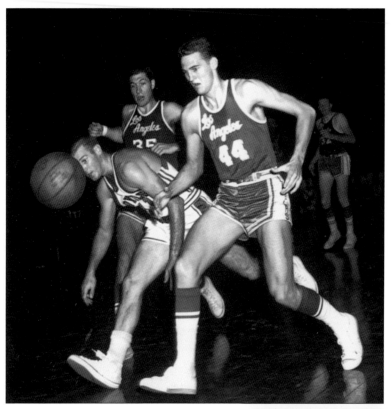

The Minneapolis Lakers gave the Royals fits during the early 1950s, but things improved a bit for Cincinnati after the Lakers moved to Los Angeles in 1960. In their first season on the West Coast, Los Angeles came back east to the Gardens to face the Royals on October 19. The top photo shows the new Laker guard, Jerry West, scrambling with the Royals' Arlen Bockhorn for the ball. That year the Royals had an 8-5 record against the Lakers. A couple of years later, as shown in the bottom photo, in another game at the Gardens, Adrian Smith (#27 for the Royals) goes up to block a shot. Despite the presence of West and the exceptional Elgin Baylor, the Lakers wouldn't bring the first NBA championship to Los Angeles until 1972 when they had Wilt Chamberlain on the roster.

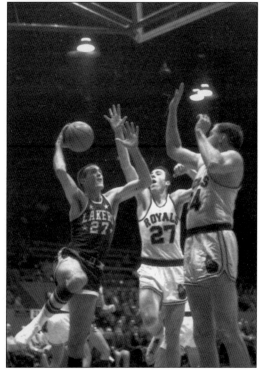

After finishing his stint with the 1964 Olympic team, George Wilson joined the hometown Royals. He enjoyed a seven-year NBA career, playing for six teams: the Royals, the Chicago Bulls, the Seattle Supersonics, the Phoenix Suns, the Philadelphia 76ers, and the Buffalo Braves. Because of the territorial draft, many collegians wound up playing for local NBA teams, and in '65-66, there were as many as five Bearcats on the Royals roster: Wilson, Tom Thacker, Connie Dierking, Oscar Robertson, and Jack Twyman

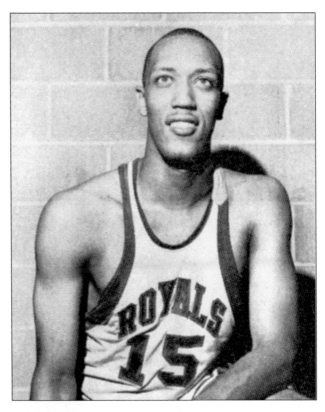

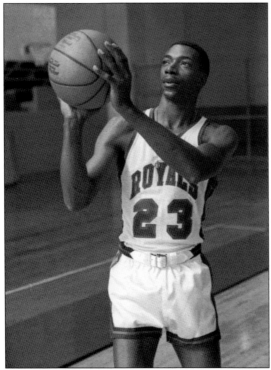

Tom Thacker joined the Royals in 1963 after graduating from UC with two national titles under his belt, and was joined by his Bearcat teammate Wilson the following season. His pro career extended for eight years, playing for the Royals, the Boston Celtics, and in the old American Basketball Association, the Indiana Pacers. Thacker also holds the distinction of being the only player ever to win NCAA, NBA, and ABA championships.

85

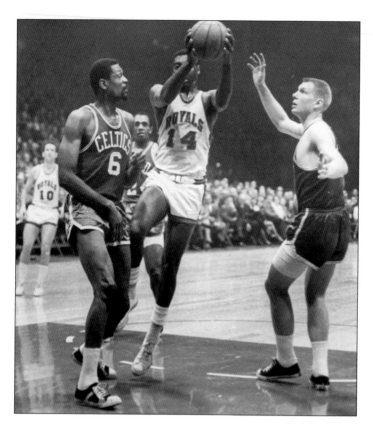

As the Cincinnati Royals built their way into the playoffs in the early 1960s, it seemed the nemesis always standing in their way was the Bill Russell-led Boston Celtics. In this Gardens game, Oscar Robertson tries to move around Russell for a lay-up. During the 1964-65 season, the Celtics won all eight of their games against the Royals. (Photo by Jack Klumpe.)

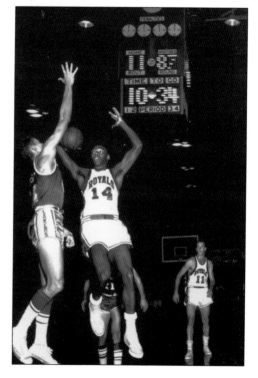

Against the Los Angeles Lakers, the Royals had only a bit more success, going 26-26 in games against them from 1960 to 1965. Here, Robertson goes for another lay-up, this time blocked by Lakers star and Robertson's 1960 Olympic teammate Jerry West.

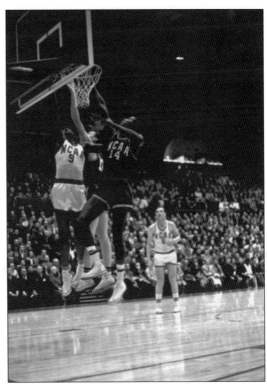

On March 26, 1964, Olympic basketball trials opened at UC's Armory Fieldhouse as part of collegiate competition for selection to the team representing America in the Tokyo games. Ron Bonham of UC was chosen to play in the game, but for some reason, George Wilson was left off the squad of local stars. Though the game only drew 3295 fans to the fieldhouse, the spectators were treated to a contest featuring John Thompson of Providence, Jim "Bad News" Barnes of Texas Western, Cotton Nash of Kentucky, and Evansville's Jerry Sloan. Bonham's "White" squad beat the "Blues," 86-85.

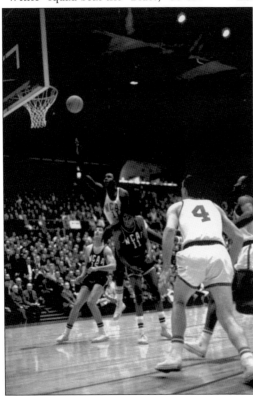

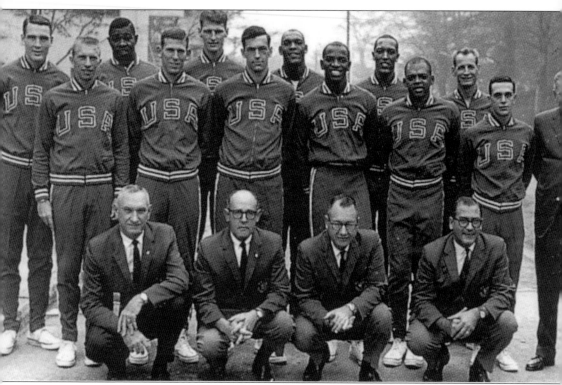

The oversight of Wilson for the Cincinnati tryout was rectified for future games when he was permitted to play. The result was that he became UC's second basketball Olympian. Oscar Robertson was the first, playing in the 1960 Rome games on a team including Jerry Lucas, Jerry West, and Walt Bellamy. Robertson averaged 17 points per game on a squad that had ten of its twelve members play in the NBA. Wilson's 1964 team, in the photo shown here (he is in the back row, fifth from the left), was also loaded with talent, like Bill Bradley, Larry Brown, Walt Hazzard, and Jim Barnes. They earned the sixth straight Gold Medal for the United States since basketball became a medal sport in the 1936 Berlin Olympics. In the 1936 "Nazi Olympics," so-called because Adolph Hitler tried to use the games to push his Aryan racism, 74-year old James Naismith was able to attend, and saw the United States win over Canada, 19-8, on a rain-soaked clay-and-sand outdoor court.

FIVE

Establishing the Strength of Local Hoops 1965–1988

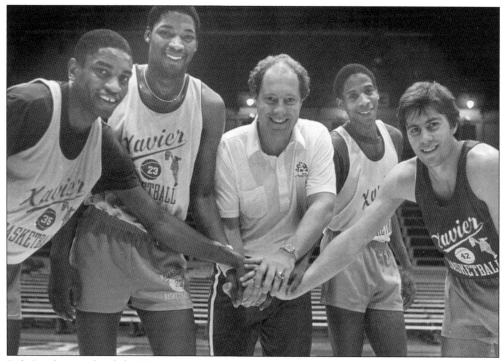

Bob Staak revitalized the Xavier program, winning 174 games from 1979 to 1985. In this photo with him are four of his outstanding players, all of whom scored more than 1,000 points each in their careers: (left to right) Dexter Bailey, Jeff Jenkins, Victor Fleming, and Gary Massa. Bailey, Jenkins, and Fleming were all selected in the 1984 NBA draft. (Photo by Jack Klumpe.)

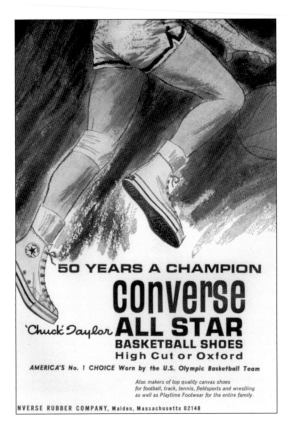

It's more than just a shoe—it's a piece of Americana. This ad for a Converse Chuck Taylor shoe from a 1965 Royals program represents a large part of basketball history. In 1923, Chuck Taylor was hired by the Converse Rubber Company away from the Akron Firestones basketball team to conduct clinics and sell the Converse line of canvas-and-rubber shoes. By 1923, they were called "Chuck Taylors" and became a fixture in gyms and on playgrounds. Chuck Taylor All-Stars were the last basketball shoe manufactured in America, ceasing domestic production in 2001. Nike bought the brand name in 2003. In 1968, Chuck Taylor the man was inducted into the Hall of Fame.

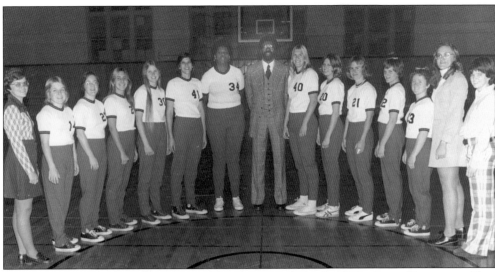

As intercollegiate basketball was revived for women in the early 1970s, former Bearcat star Tom Thacker returned in 1974 to his alma mater to coach the women's team. Thacker directed the team until 1978, with an overall record of 56-42. Here he stands with his 1975-76 squad.

Ceal Barry was named the UC women's coach for the 1979-80 season, following a one-year stint by Julienne Simpson, and promptly led the team to an 18-12 record. In her four years as coach, through 1982-83, Barry compiled a coaching record of 83-42, including a berth in the 1981 National Women's Invitational Tournament.

Joy Roberts played for the Lady Bearcats from 1980 to 1983 under Ceal Barry, scoring 1,215 points over her career. A strong rebounder as well as a consistent scorer, Roberts was inducted into the UC Athletic Hall of Fame in 1993.

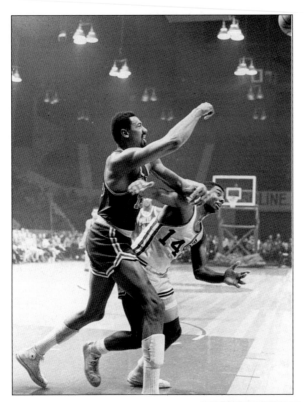

Wilt Chamberlain and Oscar Robertson tangle with each other in their struggle for the ball in a 1968 Gardens game between the Royals and the 76ers. Philadelphia won five of eight games with the Royals that year, and finished atop the Eastern Division title before losing to the Boston Celtics in the playoffs. (Photo by Jack Klumpe.)

After starring at Ohio State University, Jerry Lucas was taken in the NBA draft by the Cincinnati Royals in 1963. Lucas played until 1970 for the Royals until he was traded first to the San Francisco Warriors, and then to the New York Knicks, with whom he helped win the 1973 NBA Championship. A great rebounder, he was elected to the National Basketball Hall of Fame in 1979. In this 1968 photo, Lucas fights the Baltimore Bullets' Bob Ferry for a rebound. (Photo by Jack Klumpe.)

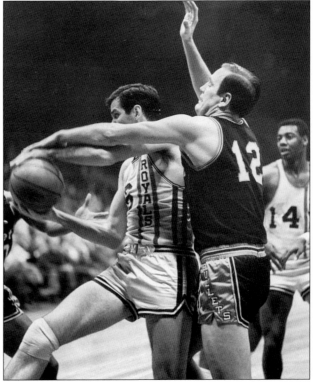

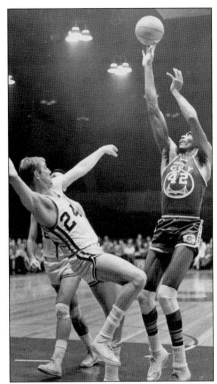

The Royals called Cincinnati home from 1957 to 1972, and for the most part during that fifteen-year span, they were sometimes playoff contenders, but mostly, just mediocre. Yet, they gave Cincinnati basketball fans the chance to see some of the greatest players in basketball history, from Bill Russell and Wilt Chamberlain to Hal Greer and Kareem Abdul-Jabbar. In these photos, a couple of other greats contend against the Royals. In the top image, the Warriors' Nate Thurmond commits an offensive foul as he maneuvers for a jumper and sends Connie Dierking flying. In the bottom photo Jerry Lucas runs into teammate Bill Dinwiddie for a rebound as New York Knicks Willis Reed and Cazzie Russell move for the ball. (Both photos by Jack Klumpe.)

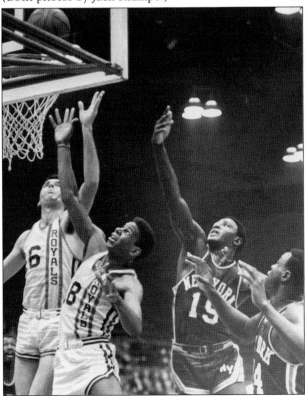

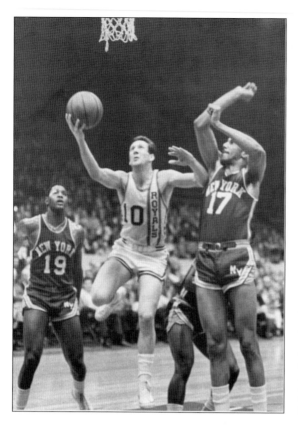

Adrian "Odie" Smith played his college ball at Kentucky, and then came to the Royals in 1961. He had a solid, steady eleven-year pro career. But 1966 was truly Smith's year. He averaged 18.4 points per game to go with an .850 free throw percentage. The NBA All-Star Game was held that year in the Gardens, and Smith was selected for the East squad. He was superlative. Scoring 25 points in the East's 137-94 victory over the West, Odie Smith was chosen the game's Most Valuable Player, becoming the third Royal in a row (Robertson in 1964, Lucas in 1965) to capture that award. In the top photo, in regular season action, Smith goes up against the Knick's Willis Reed (#19) and Nate Bowman (#17). In the bottom photo, Smith is awarded his All-Star MVP prize: a new Thunderbird convertible. His wife sits in the car for the presentation from Harry Caray as NBA President Walter Kennedy looks on. (Both photos by Jack Klumpe.)

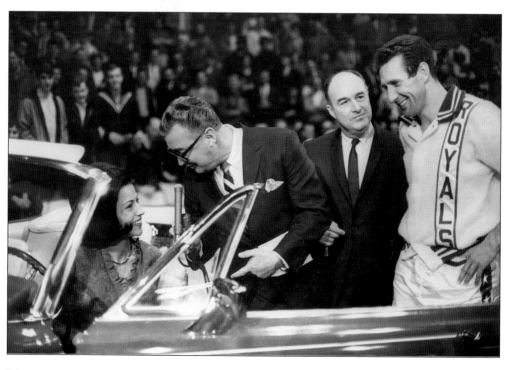

In this photo from a game during the 1966-67 season, the Royals battle the San Francisco Warriors. Jeff Mullins of the Warriors is tied up by Happy Hairston and Oscar Robertson. Robertson wound up stealing the ball as San Francisco's Fred Hetzel looks on. (Photo by Jack Klumpe.)

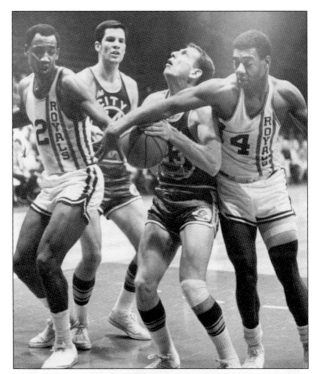

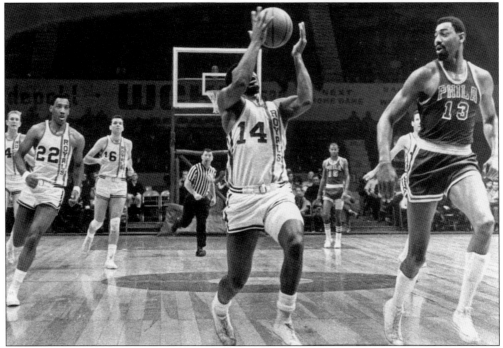

In another tilt that season, the Royals fast break the Philadelphia 76ers with Oscar Robertson taking a pass from Jerry Lucas (#16). For the Royals, Connie Dierking (#24) and Happy Hairston (#22) follow Robertson as Philly great Wilt Chamberlain tries to move into position. The 76ers's Hal Greer (#15) is in the back court. (Photo by Jack Klumpe.)

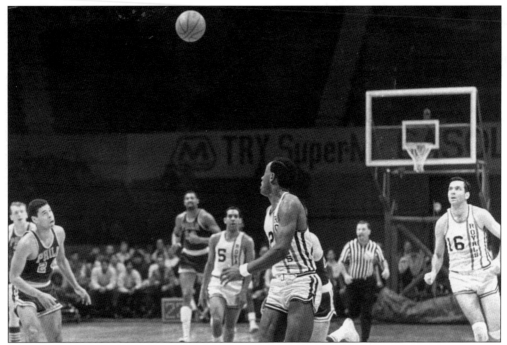

A photo of a Royals-76ers game the next year captured another Cincinnati fast break, this time with Robertson launching a long pass to Hap Hairston. Chamberlain hustles down the court behind Guy Rodgers (#5) as the ball is thrown and his teammates Billy Cunningham and Wally Jones bring up the left. Jerry Lucas (#16) is at the right. (Photo by Jack Klumpe.)

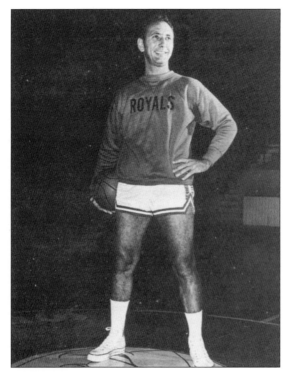

In 1969, Bob Cousy was named coach of the Royals, their sixth coach since coming to Cincinnati twelve years before. Cousy had been one of the game's best guards during his playing career with the Boston Celtics, but that success did not carry over to his coaching. His relationship with Robertson was strained, to put it kindly, and matters deteriorated when he activated himself to put a spark into the team. It didn't work. The Royals finished fifth in their division, and never were better than third. Robertson was traded to Milwaukee the following year, and Cousy was fired in 1973, a year after the Royals moved to Kansas City.

Cousy brought Draff Young to Cincinnati with him in 1969 to serve as the team's first full-time assistant coach and chief scout. Young was also the only African-American assistant coach in the NBA at that time. Previously, he had been employed by the Randolph Manufacturing Company, the firm that made Bob Cousy-brand basketball shoes, giving coaching clinics around the country. He had also spent four years with Marques Haynes and the Harlem Magicians.

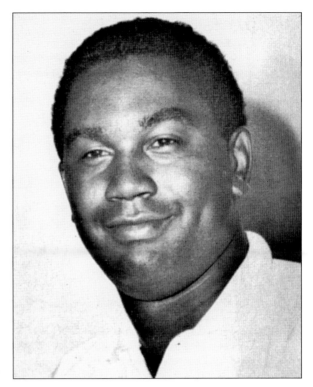

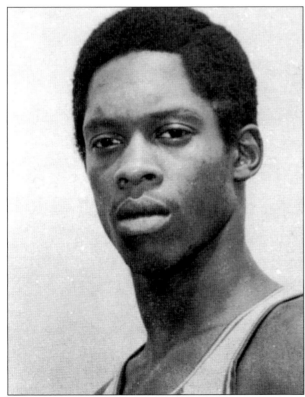

One of the bright spots on Cousy's team was Nate "Tiny" Archibald, a guard out of Texas-El Paso. Archibald came to the Royals in 1970 and played for them as they made the move west to Kansas City in 1972. A lightning-quick guard, he played in the NBA for thirteen seasons for the Royals, Nets, Celtics, and Bucks. Tiny Archibald was elected to the Hall of Fame in 1990.

Gale Catlett succeeded Tay Baker as the UC coach in 1972, and over six seasons won 126 of 170 games for a .741 winning percentage. His best year was 1976-'77 when the Bearcats were 25-5, the Metro Conference Tournament Champions, and had a bid to the NCAA. In 1978, Catlett departed UC for West Virginia University, coaching there for more than two decades.

The suit is part of history now, and as history sometimes goes, no one can remember exactly what color Bearcat coach Catlett's outfit was in the fashion of the 1970s: green and yellow checks or red and black checks? Whatever the colors, in this photo he buries his head in a towel to escape the woeful play of his team—or in a sudden realization of his fashion sense!

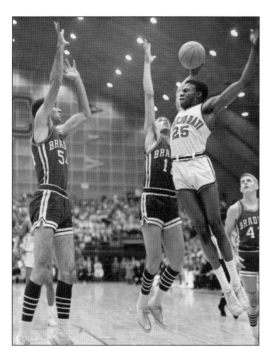

Don Ogletree was one of the stars for Tay Baker, Catlett's predecessor as the Bearcat coach, from 1965 to 1972. Ogletree was the captain of the 1969-70 UC team, averaging 13.8 points and 7.1 rebounds per game. In this photo, he is blocked by Bradley University's Greg Berry and Bob Swigris, so he passed to teammate Jim Ard for the points. (Photo by Jack Klumpe.)

Derrick Dickey was a Cincinnati high school star at Purcell before coming to UC. Each of his varsity years, from 1970 to 1973, first under Coach Tay Baker and then under Gale Catlett, Dickey averaged double-figures in points and rebounds. In this photo from the December 16, 1972 game against Davidson, Dickey goes high for a rebound in the 95-84 Bearcat victory. He finished his UC career with 1,328 points, and then played five years in the NBA with the Golden State Warriors and the Chicago Bulls.

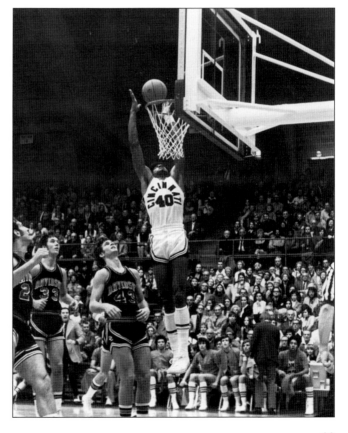

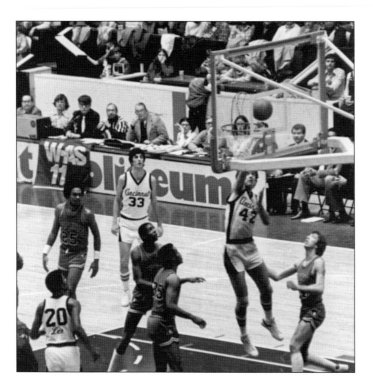

Pat Cummings scored 1,762 points as a UC Bearcat during the transition from Coach Catlett to Ed Badger, from 1974 to 1979 (including a redshirt year). Cummings was on the team at the time the Armory Fieldhouse was deemed to be too small for Bearcat fans, and home games were moved to the new Riverfront Coliseum. His strength allowed him to match up against any opponent inside the paint, and when he went to the NBA, made him a valuable sixth man. Cummings played for the Milwaukee Bucks, the Dallas Mavericks, the New York Knicks, the Miami Heat, and the Utah Jazz over a twelve-year pro career.

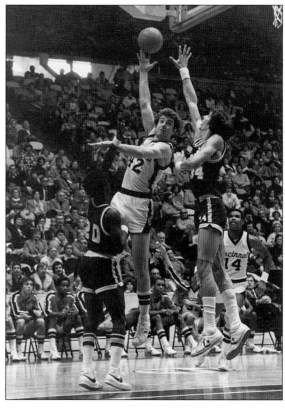

After the 1969 baseball season, some of the Cincinnati Reds decided to form a basketball team. Playing throughout Reds Country against teams of teachers, media personalities, and civic groups, the charity games saw a Reds roster that included Pete Rose, Johnny Bench, Jim Maloney, Jimmy Stewart, and Gerry Arrigo. It was fun for the players and the fans, but the next winter's hoops team saw disaster; in a January 7, 1970 game in Frankfort, Kentucky, outfielder Bobby Tolan tore his Achilles tendon. Reds management put a stop to the barnstorming, but not before "Coach" Pete Rose took them on one more tour after the '71 season.

CINCINNATI REDS
1971-72 BASKETBALL TEAM
SOUVENIR PICTURE PROGRAM

PETE ROSE – COACH

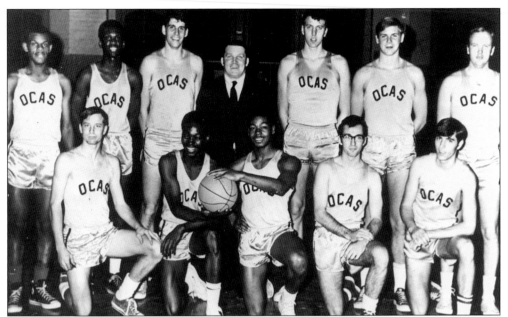

In its last season as an independent college team before joining UC in 1969, the Ohio College of Applied Science (developed from the Ohio Mechanics Institute) went out in style. The 1968-'69 OCAS Raiders won the championship of the Junior College Inter-Collegiate League with a perfect record. Kneeling, left to right, are Dan Roberts, Ed Wooten, Robert Smith, John Brecht, and Tom Cartwright. Standing, left to right, are Paul Shelton, Gordon Reed, Jerry Schutte, Coach Eugene Allison, Don Eichorst, Ed Kiffmeyer, and Gary Hornsby.

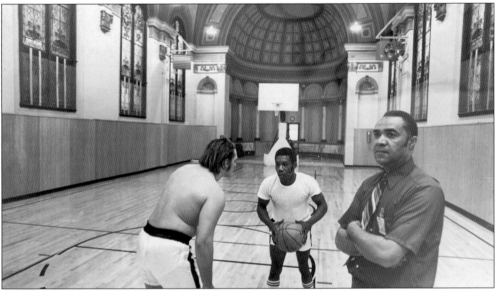

In the early days of basketball, many games were played in churches, with the pews or chairs pushed aside. In 1974, this heritage again came to the fore when the old St. Paul's Church in Over-the-Rhine was converted by the Cincinnati Recreation Commission into a youth center with a basketball court. Today the church is home to the I.T. Verdin Bell Company. (Photo by Jack Klumpe.)

Long before he became the self-proclaimed ringmaster of sleaze television, Jerry Springer was a local politician. As mayor of the city in 1978, Springer opened "Metromania Week" for the Metro Conference tournament in Cincinnati with an office foul shot. There is no record of whether the mascots attacked each other and began throwing chairs.

When Gale Catlett left UC for West Virginia, Ed Badger (pictured here) was named coach of the Bearcats in 1978. Faced with the NCAA probation that followed Catlett's tenure, Badger held the job for five years, but managed a less-than-.500 record at 68-71. It was the beginning of a decade of sub-par seasons for the 'Cats until Bob Huggins came to town in 1989.

BRADLEY vs. CINCINNATI

DECEMBER 21, 1981 OFFICIAL PROGRAM — $1

The University of Cincinnati men's team shares the record for playing in the college game with the most overtimes, and fortunately, they own the winning share. On December 21, 1981, the Bearcats tipped off against host Bradley University and ended the game *seven* overtimes later with a 75-73 victory. Sixth man Doug Schloemer tied the game in the sixth overtime with a lay-up, and his jump shot put the 'Cats ahead with just three seconds remaining in the final overtime.

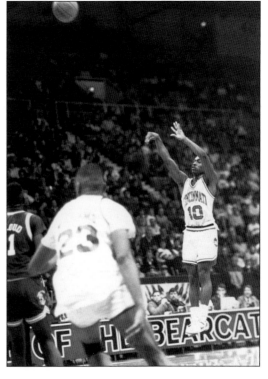

Was the fashion of long basketball shorts created in Cincinnati? The story goes that 5-foot 5-inch UC guard Romell Shorter, a Bearcat from 1985 to 1988, found himself without a uniform one game and had to make do with the only shorts available— extra big. The style caught on with players and fans around the country.

Cheryl Cook is the most outstanding player in the history of the Bearcat women's team. She scored 2,367 points in her career from 1982 to 1985 (only Oscar Robertson scored more than 2,000 points for the 'Cats). Cook was inducted into the UC Athletic Hall of Fame in 1995, and her #24 is the only women's jersey that has been retired.

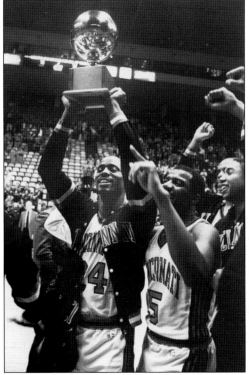

UC and XU first battled on the hardwood on March 7, 1928. Xavier won that first contest by a score of 29-25, and since then the crosstown game has been one of the most heated rivalries in the nation, between both players and fans. Through the 2002-03 season, the 'Cats and Muskies have tangled 70 times, with UC leading the series 45-25. In this 1987 photo, University of Cincinnati players raise the victor's trophy after beating Xavier 75-73 at Riverfront Coliseum.

No one has scored more points in Xavier University basketball history than Byron Larkin, whose 2,696 total reflected an average of 22.3 per game from 1984 to 1988. His high point game came during his sophomore year when he poured in 45 against Loyola of Chicago. Larkin was Second Team All-American during his senior year, after being honored twice as the Midwestern Collegiate Conference Player of the Year. His #23 has been retired (along with teammate Tyrone Hill's #42), and since 1998 Larkin has been the radio analyst for Muskie game broadcasts. (Photos courtesy of Xavier University.)

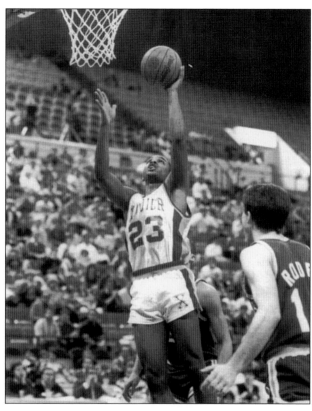

SIX

New Achievements and Hoop Madness 1989–Present

The crowd goes wild at a Bearcats game.

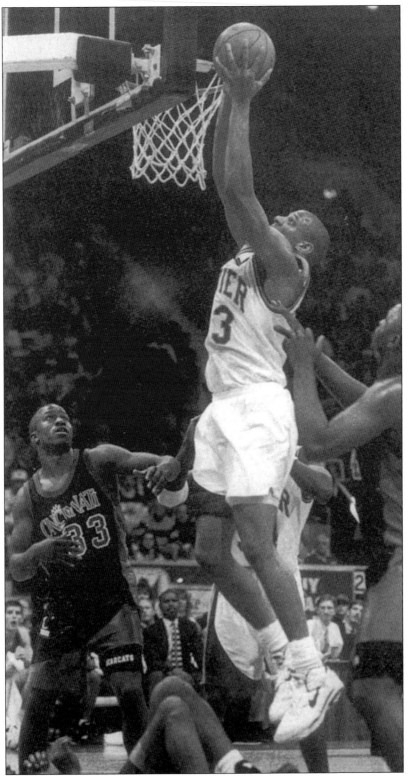

Center Brian Grant played for the XU Musketeers from 1990 to 1994, scoring 1,719 points over his collegiate career. In 1994, Grant was chosen as the eighth pick in the NBA draft by the Sacramento Kings, and has gone on to a solid pro career. (Photo courtesy of Xavier University.)

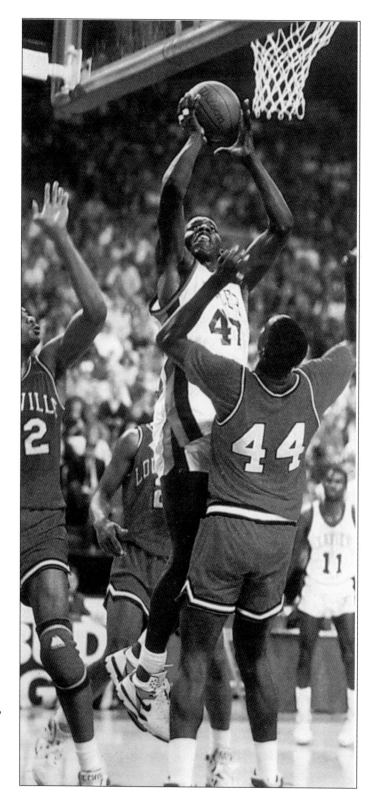

Tyrone Hill is Xavier's
second-leading scorer
of all time, trailing only
Byron Larkin. His 2,003
points pair him with
Larkin as XU's only
2,000-point scorers.
Hill's collegiate highest
scoring game was 38
points against Loyola
Marymount in 1990.
At the end of that season,
he was drafted in the
first round by the
Golden State Warriors.
(Photo courtesy of
Xavier University.)

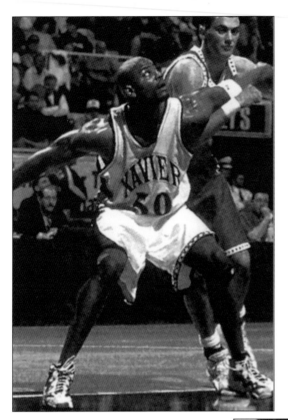

XU's Torraye Braggs was one of those power players who wasn't noted for his flamboyance, but for a steady strength in the middle. He was a key component of the '98 Muskie drive to the NCAA tournament, and was selected that year by the Utah Jazz in the NBA draft. Braggs is one of thirteen former X players with NBA service. The other twelve: Brian Grant, Michael Hawkins, Tyrone Hill, Stan Kimbrough, Malcolm McMullen, Dave Piontek, Bob Quick, Luther Rackley, Derek Strong, Larry Sykes, David West, and Aaron Williams. Piontek and Rackley played for the Royals when the franchise was in Cincinnati. (Photo courtesy of Xavier University.)

Bob Staak's legacy of building the Muskies into a conference and national power continued when he was succeeded at Xavier by Pete Gillen in 1985. Gillen coached XU until 1994 when he left for Providence, and built a record of 202 wins against 75 losses. Gillen was known in Cincinnati for his "Joe Bag of Doughnuts" approach to the game, and his sweaty, fiery red-haired stalking at courtside. (Photo courtesy of Xavier University.)

Bob Huggins came to the UC Bearcats in 1989 after successful stops as a head coach at Walsh College and the University of Akron. At the time of his arrival, the Bearcat program was in a state of disarray, with NCAA probation a close companion. Huggins didn't believe in a time for rebuilding; he said he would make the team a contender that first year, and he did, taking them to the NIT Tournament. Huggins' sideline temper during his early years became the stuff of legend. So did his success.

In 1991, Huggins landed recruit Keith Gregor, who would give him four years of hard-nosed defense. Gregor was also a durable player, ranking second all-time in UC games with 131. In this image from the January 29, 1994 game, Gregor dribbles around a DePaul defender. The 'Cats beat the Blue Demons, 66-43. (Photo by Colleen Kelley, University of Cincinnati.)

One of the reasons for Huggins's success was his recruitment of junior college players, who brought to UC some college seasoning. One of the best was Nick Van Exel. Arriving from Trinity Valley, Texas Community College in 1991, Van Exel helped propel the team into the '92 NCAA Final Four. In this 1993 photo, Van Exel penetrates the Saint Louis Billiken defense during the Great Midwest Tournament.

Tarrance Gibson was another stalwart who was on the '92 Final Four team and the Elite Eight team the Bearcats had the following year. Here, he pushes for a lay up in the Crosstown Shootout with Xavier in 1993. UC won this battle, 78-67. (Photo by Lisa Ventre, University of Cincinnati.)

In that same cross-town match-up, forward Erik Martin, a juco transfer to UC, snatches a rebound as teammate Corie Blount backs away from him. (Photo by Lisa Ventre, University of Cincinnati.)

Kenyon Martin cemented his place in Cincinnati basketball history his senior year as a UC Bearcat. Martin steadily improved year-after-year under the coaching of Bob Huggins, and by his final campaign in 1999-2000, he was the consensus Player of the Year in college hoops. It was his ferocious, joyous play that endeared him to local fans. Stretching his tattooed torso high in the air on defense, he swatted shot after shot away from the basket, and then hooted and mugged for the stands and television cameras. In the end, he established the all-time Bearcat record for blocked shots with 292. Martin led his team into the 2000 Conference USA tournament with a 28-2 record, but a broken leg in the game against Saint Louis ended his college career, and all but dashed UC's hope for much success in the NCAA tourney. Taken in the NBA draft by the New Jersey Nets, that same Martin ferocity under the boards during his first two seasons led to a number of flagrant fouls and a suspension. But he was always a quick study: with maturity came control and enhanced professional skills, so that in 2002 and 2003 Martin was an important reason why the Nets made the NBA Finals. (Photo by Lisa Ventre, University of Cincinnati.)

On the women's side, the Bearcats continued to seek consistent success in the early 1990s. In this photo, center Angel Minton (#32) fights for a rebound in an 82-80 victory over Eastern Kentucky. Minton scored 20 points and grabbed nine boards in the win. (Photo by Colleen Kelley, University of Cincinnati.)

In a game against the University of Alabama-Birmingham in 1994, UAB's Valecia Buckner is battled for the ball by Bearcat Elaine Blake. Blake played for Coach Laurie Pirtle from 1991 to 1994, and at the conclusion of her career, was the all-time assists leader with 466. (Photo by Lisa Ventre, University of Cincinnati.)

ALL CITY Spring 3 on 3 Basketball Tournament & Jam

Basketball has always been viewed as a unifier in American society. From its earliest days in the 1890s, the game was used to "Americanize" the country's immigrant children, and to bridge gaps between social, racial, and economic groups. In recent years, Midnight Basketball Leagues in Cincinnati and around the country have used hoops to reduce crime and increase social responsibility. New York City's Increase the Peace League narrowed in on Black-Jewish relations, and in Cincinnati, efforts have been made along the same line, such as with the annual tournament in the suburban community of Wyoming organized by Cincinnatian David Rich. The three-on-three tourney started in 1991 with the intent of African American and white players coming together on teams in the hope that it would lead to a greater understanding between them. In the light of Cincinnati's increased racial strife in recent years, other tournaments, such as these poster advertisements for the West End YMCA, emphasized basketball's reflection of urban culture and unity.

COHHIO
YEP
Youth Empowerment Program

THE C.O.H.H.I.O. YOUTH EMPOWERMENT PROGRAM IS PLEASED TO PRESENT:

COMMUNITY UNITY
BASKETBALL TOURNAMENT

smoking NOT included

Unlike advertisements in previous decades that used basketball as a means to market tobacco, this ad used the sport to discourage tobacco use. As the game became more and more integrated into the American culture of sport, basketball also began to reflect societal concerns. With the rise of anti-smoking messages directed at teenagers, this poster was placed in area high school classrooms around the city in 2001.

In recognition of Oscar Robertson's place in the history of Bearcat basketball, the University of Cincinnati dedicated a statue of the legendary player in 1994. One of only two statues on campus (the other is of William Howard Taft, outside the College of Law), Robertson's bronze is located on the east side of UC's basketball arena.

Another attempt at professional basketball in Cincinnati was launched in 1999 as a team in the International Basketball League, a minor league circuit with a roster of former local collegians. Melvin Levitt, a fan favorite when he played at the University of Cincinnati, was selected as the first draft pick by the new team, which played its games at Riverfront Coliseum. The Stuff never caught on, however, and by 2001 they were gone. The team followed the demise of another minor league franchise in Cincinnati, the Slammers who played at the Gardens in the Continental Basketball League from 1984 to 1987. The Stuff was followed in the Cincinnati area by the Kentucky ProCats, which lasted for only the 2000-01 season.

Melanie Balcomb became the coach of XU's women Musketeers in 1995, leading the Muskies into consistent national tourney competition, and amassing a record of 135-78. She resigned from XU in 2002 to coach Vanderbilt University and Kevin McDuff became the new head coach, guiding the team to a 20-10 record in his first year. Before Balcomb left Xavier, she recruited Tara Boothe, who also had a great first year, earning Freshman All-American honors. Boothe won 11 Rookie of the Week awards in the Atlantic 10 Conference, and averaged 16 points per game. (Photo courtesy of Xavier University.)

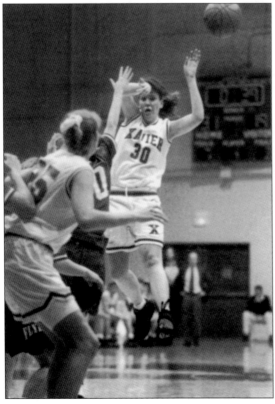

Xavier's Carol Madsen (1991-1994) was one of the Muskie's great playmakers. When she completed her XU days, she held the team's all-time record with 518 assists. She also scored 1,702 points. Madsen set the example for two other great point guards who followed her, Nikki Kremer (1995-1999) and Amy Waugh (1999-2003). (Photo courtesy of Xavier University.)

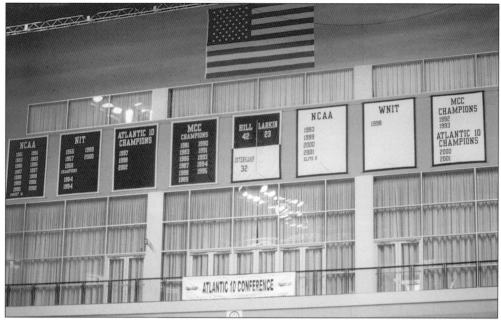

Xavier University dedicated its Cintas Center in 2000, bringing back the Musketeers to campus for the first time since 1984. Seating 10,250 fans, the Cintas Center provided them with looks at some of Musketeer basketball championship banners, and Xavier opened the arena with a 68-54 win over Miami University on November 18. The Cintas hosted its first major basketball tournament in November 2003, with the Black Coaches Association Classic.

In this photo from a game against Rhode Island on January 26, 2003, Xavier point guard Amy Waugh (#3) waits for the ball to be put in play. The senior Waugh finished her collegiate career with 1,523 points and a school-record 107 three-pointers. Waugh and her backcourt mate, Reeta Piipari, both went over the 1,000-point mark in the same game, against Colorado State on November 30, 2002. They became the nation's only active backcourt tandem with more than 1,000 points and 500 assists each.

Skip Prosser was head coach of the Xavier Musketeer's men's squad from 1994 to 2001, following Pete Gillen. In those years, Prosser coached XU to 148 wins against 65 losses, five straight 20-win seasons, and saw his team invited to four NCAA and two NIT tournaments. Prosser was a Gillen assistant for many years, and one of the most popular coaches in Muskie history, and, in Cincinnati basketball. Prosser moved on to Wake Forest University and the Atlantic Coast Conference and was replaced by Thad Matta, who ably continued the XU success in 2002 and 2003. (Photo courtesy of Xavier University.)

Before a game against Temple University on March 8, 2003, Xavier retired David West's jersey, No. 30, joining Byron Larkin, Tyrone Hill, and Jo Ann Osterkamp's No. 32. West was the player for XU that Kenyon Martin was for the UC Bearcats. Reaping some of the same awards as Martin—the AP National Player of the Year, the Oscar Robertson Player of the Year—West is the only player in Atlantic 10 Conference history to have 2,000 points and 1,000 rebounds in his career. He was selected by the New Orleans Hornets with the 18th pick in the 2003 NBA draft. (Photo courtesy of Xavier University.)

Cincinnati State Technical and Community College built one of the premier junior college programs in the Midwest in the 1990s. Gary McDaniel began coaching the Lady Surge in 1993, and has produced seven All-American and 21 All-Regional players. In the top photo, he talks to his team during the timeout of a game against Lakeland Community College. In the bottom image, Khaleelah Head shoots a foul shot in the 60-49 victory over Lakeland. For the men's team, Coach John Hurley spent 26 years at Cincinnati State through the 2002-03 season and amassed over 500 victories. In 2003, he took over the helm of the Cougars at the University of Cincinnati's Clermont College.

A legend in Cincinnati high school hoops, Mary Jo Huismann of Mercy High School won over 500 games in a career stretching back to 1971. At the age of 24, Husimann was coaching both Mercy and the University of Cincinnati women's team. In 1975, she gave up the Bearcat job to Tom Thacker, and concentrated on prep basketball. Under Husimann's coaching, and that of her 21-year assistant, Dick Bley, Mercy won fifteen league championships and three Ohio state runner-up titles. (Photo courtesy of Mary Jo Huismann.)

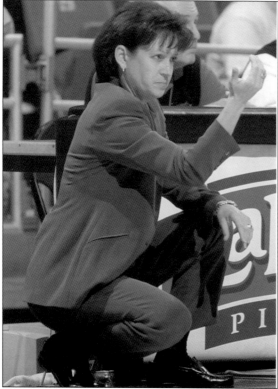

Laurie Pirtle, the women's basketball coach at the University of Cincinnati since 1986, won 254 games through the 2002-03 season, and led the team to nine post-season tournament appearances. Pirtle's bold intensity on the court represented just one aspect of her coaching acumen: with Title IX equalizing resources for women's college sports in the last generation, Pirtle consistently recruited the players necessary for winning teams. (Photo by Andrew Higley, University of Cincinnati.)

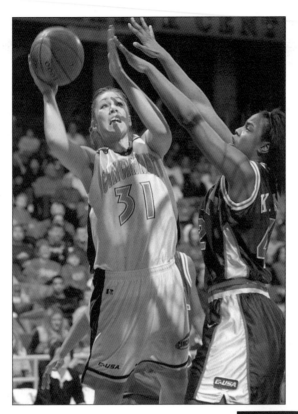

Debbie Merrill was one of those outstanding Pirtle recruits The 6-foot 3-inch center from Tennessee was highly recruited by several schools, and chose UC. In her first season, Merrill was named the 2001-'02 Conference USA Freshman of the Year, and garnered Third Team Freshman All-American honors. (Photo by Andrew Higley, University of Cincinnati.)

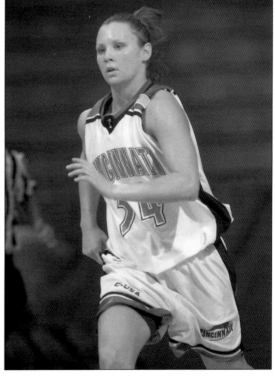

A three-point specialist, Valerie King of the Bearcats won the Basketball Hall of Fame's Ed Steitz Award in 2002 as the top long-range shooter in the nation. That season, King poured in 39 points against Butler University, and through her junior season in 2002-'03, had scored 1661 points in her career. ((Photo by Andrew Higley, University of Cincinnati.)

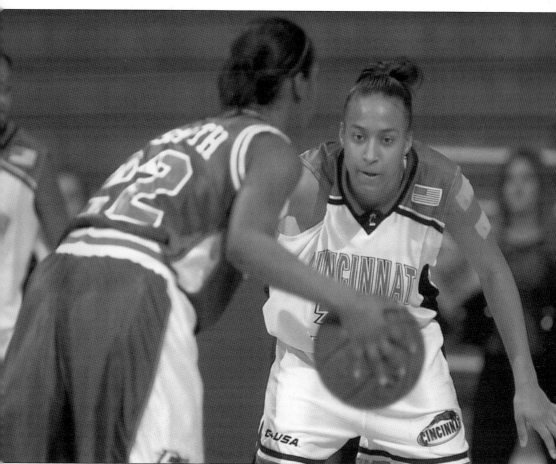

K.B. Sharp was a three-year starter for the UC Bearcats during here career from 1999 to 2003. In her senior year, the 5-foot 9-inch guard averaged almost six assists per game, while putting up 423 points. The spark plug for a team that was 23-8 in 2002-03 and went to its sixth straight post-season tournament, Sharp joined the thousand-point club with a career total of 1164 and also became the all-time assist leader with 623. Sharp became the second UC player selected in the WNBA draft (preceded by Madinah Slaise by the Detroit Shock in 2000) when she was chosen in the second round by the New York Liberty in 2003, and during her first pro season was a significant player off the bench. (Photo by Andrew Higley, University of Cincinnati.)

In a photograph taken before the 2002-03 season, Bob Huggins shares a laugh with assistant Andy Kennedy before a scrimmage. Since he came to the University of Cincinnati in 1989, Huggins has gone over the 500-win mark for total victories, and become the all-time winning Bearcat coach with 349 victories. He has also led the team to post-season NCAA and NIT tournament berths every single year of his tenure on the Clifton campus. (Photo by Lisa Ventre, University of Cincinnati.)

The Citywide AA Basketball League is a Cincinnati summer institution. Created in 1986 by Dennis Bettis, Butch Burbridge, Ralph Lee, and Derek Davis, the league's initial purpose was to provide structure to the games being played by incoming college players, some seasoned collegians, and even a few pros with local connections. For many years the games were held at Purcell-Marian High School. Fans caught on to the summer action, and the heat in the Purcell gym became part of the experience; the stifling Cincinnati July weather actually felt cool after leaving the Purcell steam bath. Since 2001, the league, now sponsored by Deveroes Stores, has been held in the air-conditioned Oak Hills High School gym. In this photo from the 2003 action, Xavier University's Romain Sato shoots a foul shot in a game between his Cintas team and the Stratus Group squad.

Jack "Truck" Jennings personifies the great experience of Cincinnati hoops. A graduate of Holmes High School in northern Kentucky, Jennings played his college ball at Western Kentucky University. He has played professionally overseas since 1992, mainly in Israel. Every summer, the 6-foot 5-inch, 270 pound (which may be a low estimate) Jennings comes home to play in the CityWide games where he joins other players with a long attachment to the league, like Chuck Broadnax and Kevin Britten. With his massive bulk careening into the paint like an unbalanced lumber truck, Jennings uses his pro experience to intimidate opponents and move them out of the way. He muscles down rebounds, or pulls up for a soft three-pointer. The fans shout and cheer, and summer in Cincinnati is great. In the 2003 championship game, Jennings led his undefeated Maaco-Blue Ash team to a 113-110 victory over Stratus Group. Truck scored 28 points and won the tourney Most Valuable Player award.

Notes for Further Reading

For a very good general history of sports in America, including the development of basketball, see Benjamin G. Rader's *American Sports: From the Age of Folk Games to the Age of Televised Sports*, 5th ed. (Upper Saddle River, NJ, 2003). Also helpful is a book by Steven A. Riess, *City Games: The Evolution of American Urban Society and the Rise of Sports* (Urbana, IL, 1989).

Excellent information about the early history of basketball and its subsequent growth can be found in James Naismith's *Basketball: Its Origin and Development* (first published in 1941, subsequently reprinted, Lincoln, NE, 1996) and *The Amazing Basketball Book: The First 100 Years*, 2nd ed., by Bob Hill and Randall Baron (Louisville, KY, 1988). Essential research on professional basketball begins with Robert Bradley's *Compendium of Professional Basketball* (Tempe, AZ, 1999), Ron Smith's *Ultimate Encyclopedia of Basketball: The Essential Guide to the NBA* (New York, NY, 1996), *The Sports Encyclopedia: Pro Basketball, 1891-1990*, 3rd ed., by David S. Neft and Richard M. Cohen (New York, NY, 1990), and *The 2002-03 Official NBA Guide*, ed. by Craig Carter and Rob Reheuser (New York, NY, 2002). For solid histories of the NBA, including its integration, see Robert W. Peterson's *Cages to Jump Shots: Pro Basketball's Early Years* (New York, NY, 1990), Leonard Koppett's *24 Seconds to Shoot: The Improbable Rise of the National Basketball Association* (Kingston, NY, 1999, first published 1968), and *They Cleared the Lane: The NBA's Black Pioneers* by Ron Thomas (Lincoln, NE, 2002).

To learn more about women and basketball, see Joanne Lannin's *A History of Basketball for Girls and Women: From Bloomers to Big Leagues* (Minneapolis, MN, 2000), and *The 2003 Official WNBA Guide and Register*, ed. by John Maxwell, Steve Meyerhoff, and Jeanne Tang (New York, NY, 2003).

Neil D. Isaacs's *All the Right Moves: A History of College Basketball* (Philadelphia, PA, 1975) is a good readable history, and two books thoroughly document the college basketball gambling scandals of the 1950s: Stanley Cohen's *The Game They Played* (New York, NY, 1977) and Charley Rosen's *Scandals of '51: How the Gamblers Almost Killed College Basketball* (New York, NY, 1978 and 1999). The best overall treatment of sports gambling is *Betting the Line: Sports Wagering in American Life* by Richard O. Davies and Richard G. Abram (Columbus, OH, 2001).

For a general view of Cincinnati sports history, including basketball, see *Cincinnati on Field and Court: The Sports Legacy of the Queen City* by Kevin Grace (Chicago, IL, 2002). *Bearcats! The Story of Basketball at the University of Cincinnati* by Kevin Grace, Greg Hand, Tom Hathaway, Carey Hoffman, and Lisa Souders (Louisville, KY, 1998), along with three other books, Ed Jucker's instructional *Cincinnati Power Basketball* (Englewood Cliffs, NJ, 1962), *Bob Huggins: Pressed for Success* by Bob Huggins and Mike Bass (Champaign, IL, 1995), and Alex Meacham's *Walk of a Lifetime: An Inspirational Journey from a Shattered Dream to the Cincinnati Bearcats* (Cincinnati, OH, 2000) provide good views of the UC basketball heritage.

For the career and legacy of Oscar Robertson, see *But They Can't Beat Us: Oscar Robertson and the Crispus Attucks Tigers* by Randy Roberts (Champaign, IL, 1999), Ira Berkow's *Oscar Robertson: The Golden Year, 1964* (Englewood Cliffs, NJ, 1971), and Robertson's autobiography, *The Big O* (Emmaus, PA, 2003).